THE AGILE RABBIT
VISUAL DICTIONARY OF

FRUIT

BILDWÖRTERBUCH OBST
DICTIONNAIRE VISUEL DES FRUITS
DIZIONARIO VISUALE DELLA FRUTTA
DICCIONARIO VISUAL DE LAS FRUTAS
DICIONÁRIO VISUAL DA FRUTA
AGILE RABBIT可视水果词典
フルーツ写真

THE PEPIN PRESS | AGILE RABBIT EDITIONS

Graphic Themes & Pictures

1000 Decorated Initials
Graphic Frames
Images of the Human Body
Geometric Patterns
Menu Designs
Classical Border Designs
Signs & Symbols
Bacteria And Other Micro Organisms
Occult Images
Erotic Images & Alphabets
Fancy Alphabets
Mini Icons
Graphic Ornaments
Compendium of Illustrations
5000 Animals
Teknological
Skeletons

Styles (Historical)

Early Christian Patterns
Byzantine
Romanesque
Gothic
Mediæval Patterns
Renaissance
Baroque
Rococo
Patterns of the 19th Century
Art Nouveau Designs
Fancy Designs 1920
Patterns of the 1930s
Art Deco Designs

Styles (Cultural)

Chinese Patterns
Ancient Mexican Designs
Japanese Patterns
Traditional Dutch Tile Designs
Islamic Designs
Persian Designs
Turkish Designs
Elements of Chinese
 & Japanese Design
Arabian Geometric Patterns
Barcelona Tile Designs
Tile Designs from Portugal

Textile Patterns

Batik Patterns
Weaving Patterns
Lace
Embroidery
Ikat Patterns
Indian Textile Prints
Indian Textiles
Kimono Patterns
European Folk Patterns
Flower Power

Folding & Packaging

How To Fold
Folding Patterns
 for Display & Publicity
Structural Package Designs
Mail It!
Special Packaging

Web Design

Web Design Index 5
Web Design Index 6
Web Design Index by Content
Web Design Index by Content.02

Photographs

Fruit
Vegetables
Body Parts
Male Body Parts
Body Parts in Black & White
Images of the Universe
Rejected Photographs
Flowers

Miscellaneous

Floral Patterns
Astrology
Historical & Curious Maps
Atlas of World Mythology
Images from the Bible
Wallpaper Designs
Watercolour Patterns

More titles in preparation. In addition
to the Agile Rabbit series of book +CD-
ROM sets, The Pepin Press publishes
a wide range of books on art, design,
architecture, applied art, and popular
culture.

Please visit www.pepinpress.com for
more information

COLOPHON

Copyright © 2006 Pepin van Roojen & Günter Beer
All rights reserved.

The Pepin Press | Agile Rabbit Editions
P.O. Box 10349
1001 EH Amsterdam, The Netherlands

Tel +31 20 420 20 21
Fax +31 20 420 11 52
mail@pepinpress.com
www.pepinpress.com

Series editor & designer: Pepin van Roojen
Photography & layout: Günter Beer

Translations: LocTeam, Barcelona
(Spanish, Italian, French, Portuguese, and German),
Michie Yamakawa, Tokyo (Japanese),
and TheBigWord, Leeds (Chinese)

ISBN 978 90 5768 047 2

10 9 8 7 6 5 4 3 2 1
2012 11 10 09 08 07 06

Manufactured in Singapore

CONTENTS

Introduction in English 4
Introducción en español 5
Einführung auf Deutsch 6
Introduction en français 7
Introduzione in italiano 8
Introdução em português 9
日本語による序文 10
中文前言 11

Pictures

12

52

98

138

142

172

196

Index 218

Free CD-Rom in the inside back cover

FRUIT & VEGETABLES

Images of fruit and vegetables are popular as illustrations not only for recipes, menus and cookbooks, but also for postcards, invitations and T-shirts. These book and CD sets include reproductions of 250 high-quality fruit and vegetable photographs ranging from common to highly exotic species. Added value lies in the multilingual captions, hence the term Visual Dictionary.

BOOK AND CD-ROM

The images in this book can be used as a graphic resource and for inspiration. All the illustrations are stored in high-resolution format on the enclosed free CD-ROM and are ready to use for professional quality printed media and web page design.

The pictures can also be used to produce postcards, either on paper or digitally, or to decorate your letters, flyers, etc. They can be imported directly from the CD into most design, image-manipulation, illustration, word-processing and email programs. Some programs will allow you to access the images directly; in others, you will first have to create a document, and then import the images. Please consult your software manual for instructions.

The names of the files on the CD-ROM correspond with the page numbers in this book. The CD-ROM comes free with this book, but is not for sale separately. The publishers do not accept any responsibility should the CD not be compatible with your system.

For non-professional applications, single images can be used free of charge. The images cannot be used for any type of commercial or otherwise professional application – including all types of printed or digital publications – without prior permission from The Pepin Press / Agile Rabbit Editions.

The files on Pepin Press / Agile Rabbit CD-ROMs are high quality and sufficiently large for most applications. However, larger and/or vectorised files are available for most images and can be ordered from The Pepin Press / Agile Rabbit Editions.

For inquiries about permissions and fees, please contact:
mail@pepinpress.com
Fax +31 20 4201152

FRUTAS Y VERDURAS

El uso de imágenes de frutas y verduras es un recurso muy habitual para ilustrar no solo recetas, menús y libros de cocina, sino también postales, invitaciones y camisetas. Estos volúmenes, que incluyen libro y CD, contienen reproducciones de 250 fotografías de alta calidad de una amplia variedad de especies de frutas y verduras, desde las más comunes a las más exóticas. Además, los pies de foto multilingües suponen un valor añadido; de ahí el término "Diccionario visual".

LIBRO Y CD-ROM

En este libro podrá encontrar imágenes que le servirán como fuente de material gráfico o como inspiración para realizar sus propios diseños. Se adjunta un CD-ROM gratuito donde hallará todas las ilustraciones en un formato de alta resolución, con las que podrá conseguir una impresión de calidad profesional y diseñar páginas web.

Las imágenes pueden también emplearse para realizar postales, de papel o digitales, o para decorar cartas, folletos, etc. Se pueden importar desde el CD a la mayoría de programas de diseño, manipulación de imágenes, dibujo, tratamiento de textos y correo electrónico, sin necesidad de utilizar un programa de instalación. Algunos programas le permitirán acceder a las imágenes directamente; otros, sin embargo, requieren la creación previa de un documento para importar las imágenes. Consulte su manual de software en caso de duda.

Los nombres de los archivos del CD-ROM se corresponden con los números de página de este libro. El CD-ROM se ofrece de manera gratuita con este libro, pero está prohibida su venta por separado. Los editores no asumen ninguna responsabilidad en el caso de que el CD no sea compatible con su sistema.

Se autoriza el uso de estas imágenes de manera gratuita para aplicaciones no profesionales. No se podrán emplear en aplicaciones de tipo profesional o comercial (incluido cualquier tipo de publicación impresa o digital) sin la autorización previa de The Pepin Press / Agile Rabbit Editions.

Los archivos incluidos en los CD-ROM de Pepin Press/Agile Rabbit son de alta calidad y de tamaño suficiente para cualquier utilidad. No obstante, pueden solicitarse a The Pepin Press/Agile Rabbit Editions archivos de mayor tamaño o archivos vectorizados de prácticamente todas las imágenes.

Para más información acerca de autorizaciones y tarifas:

mail@pepinpress.com
Fax +31 20 4201152

OBST UND GEMÜSE

Obst- und Gemüsebilder werden nicht nur zur Illustration von Rezepten, Speisekarten, Kochbüchern etc. sondern auch zur Gestaltung von Postkarten, Einladungen und T-Shirts verwendet. Diese Buch + CD Sets enthalten 250 qualitativ hochwertige Obst- und Gemüsefotografien, wobei das Spektrum von sehr bekannten bis hin zu ausgesprochen exotischen Sorten reicht. Ein besonderer Zusatzwert liegt in den mehrsprachigen Bildunterschriften – daher auch die Bezeichnung Bildwörterbuch.

BUCH UND CD-ROM

Dieses Buch enthält Bilder, die als Ausgangsmaterial für graphische Zwecke oder als Anregung genutzt werden können. Alle Abbildungen sind in hoher Auflösung auf der beiliegenden Gratis-CD-ROM gespeichert und lassen sich direkt zum Drucken in professioneller Qualität oder zur Gestaltung von Websites einsetzen.

Sie können sie auch als Motive für Postkarten auf Karton oder in digitaler Form, oder als Ausschmückung für Ihre Briefe, Flyer etc. verwenden. Die Bilder lassen sich direkt in die meisten Zeichen-, Bildbearbeitungs-, Illustrations-, Textverarbeitungs- und E-Mail-Programme laden, ohne dass zusätzliche Programme installiert werden müssen. In einigen Programmen können die Dokumente direkt geladen werden, in anderen müssen Sie zuerst ein Dokument anlegen und können dann die Datei importieren. Genauere Hinweise dazu finden Sie im Handbuch zu Ihrer Software.

Die Namen der Bilddateien auf der CD-ROM entsprechen den Seitenzahlen dieses Buchs. Die CD-ROM wird kostenlos mit dem Buch geliefert und ist nicht separat verkäuflich. Der Verlag haftet nicht für Inkompatibilität der CD-ROM mit Ihrem System.

Für nicht professionelle Anwendungen können einzelne Bilder kostenfrei genutzt werden. Die Bilder dürfen ohne vorherige Genehmigung von The Pepin Press / Agile Rabbit Editions nicht für kommerzielle oder sonstige professionelle Anwendungen einschließlich aller Arten von gedruckten oder digitalen Medien eingesetzt werden.

Die Dateien auf den CD-ROMs sind in Bezug auf Qualität und Größe für die meisten Anwendungsbereiche geeignet. Zusätzlich können jedoch größere Dateien oder Vektorgrafiken der meisten Bilder bei The Pepin Press/Agile Rabbit Editions bestellt werden.

Für Fragen zu Genehmigungen und Preisen wenden Sie sich bitte an:
mail@pepinpress.com
Fax +31 20 4201152

FRUITS & LÉGUMES

Les images de fruits et légumes illustrent couramment les recettes, menus, livres de cuisine, etc. mais aussi les cartes postales, cartons d'invitation et tee-shirts. Dans ces coffrets livre et CD, 250 photographies de haute qualité de fruits et de légumes sont reproduites et classées des variétés les plus communes aux plus exotiques. Des légendes en plusieurs langues ajoutent à sa valeur ; d'où le terme de dictionnaire visuel.

LIVRE ET CD-ROM

Cet ouvrage renferme des illustrations destinées à servir d'inspiration ou de ressources graphiques. Toutes les images sont stockées en format haute définition sur le CD-ROM et permettent la réalisation d'impressions de qualité professionnelle et la création de pages web. Elles permettent également de créer des cartes postales, aussi bien sur papier que virtuelles, ou d'agrémenter vos courriers, prospectus et autres.

Vous pouvez les importer directement à partir du CD dans la plupart des applications de création, manipulation graphique, illustration, traitement de texte et messagerie. Certaines applications permettent d'accéder directement aux images, tandis qu'avec d'autres, vous devrez d'abord créer un document, puis y importer les images. Veuillez consulter les instructions dans le manuel du logiciel concerné.

Sur le CD, les noms des fichiers correspondent aux numéros de pages du livre.

Le CD-ROM est fourni gratuitement avec le livre et ne peut être vendu séparément. L'éditeur décline toute responsabilité si ce CD n'est pas compatible avec votre ordinateur. Vous pouvez utiliser les images individuelles gratuitement avec des applications non-professionnelles. Il est interdit d'utiliser les images avec des applications de type professionnel ou commercial

(y compris avec tout type de publication numérique ou imprimée) sans l'autorisation préalable des éditions Pepin Press / Agile Rabbit.

Les fichiers figurant sur les CD-ROM Pepin Press/Agile Rabbit sont de haute qualité et d'une taille acceptable pour la plupart des applications. Cependant, des fichiers plus volumineux et/ou vectorisés sont disponibles pour la plupart des images. Vous pouvez les commander auprès des Éditions The Pepin Press/Agile Rabbit.

Adresse électronique et numéro de télécopie à utiliser pour tout renseignement relatif aux autorisations et aux frais d'utilisation :
mail@pepinpress.com
Télécopie : +31 20 4201152

FRUTTA E VERDURE

Le immagini di frutta e verdure sono molto utilizzate per decorare non solo ricette, menù e libri di cucina, ma anche cartoline, biglietti invito e magliette. Ogni libro con CD contiene 250 fotografie di alta qualità di frutta e verdure, dalle specie più comuni a quelle più esotiche; inoltre, le didascalie in diverse lingue ne fanno un vero e proprio Dizionario Visuale.

LIBRO E CD-ROM

Questo libro contiene immagini che possono essere utilizzate come risorsa grafica o come fonte di ispirazione. La maggior parte delle illustrazioni sono contenute nel CD–ROM gratuito allegato, in formato ad alta risoluzione e pronte per essere utilizzate per pubblicazioni professionali e pagine web.

Possono essere inoltre usate per creare cartoline, su carta o digitali, o per abbellire lettere, opuscoli, ecc.

Dal CD, le immagini possono essere importate direttamente nella maggior parte dei programmi di grafica, di ritocco, di illustrazione, di scrittura e di posta elettronica; non è richiesto alcun tipo di installazione. Alcuni programmi vi consentiranno di accedere alle immagini direttamente; in altri, invece, dovrete prima creare un documento e poi importare le immagini. Consultate il manuale del software per maggiori informazioni.

I nomi dei file del CD-ROM corrispondono ai numeri delle pagine del libro. Il CD–ROM è allegato gratuitamente al libro e non può essere venduto separatamente. L'editore non può essere ritenuto responsabile qualora il CD non fosse compatibile con il sistema posseduto.

Per le applicazioni non professionali, le singole immagini possono essere usate gratis. Per l'utilizzo delle immagini a scopo professionale o commerciale, comprese tutte le pubblicazioni digitali o stampate, è necessaria la relativa autorizzazione da parte della casa editrice The Pepin Press / Agile Rabbit Editions.

I file contenuti nei CD-ROM di Pepin Press/Agile Rabbit sono di alta qualità e di dimensioni sufficienti per le applicazioni più comuni. Tuttavia, per la maggior parte delle immagini, è possibile richiedere a The Pepin Press/ Agile Rabbit Editions file più grandi e/o vettorializzati.

Per ulteriori informazioni rivolgetevi a:
mail@pepinpress.com
Fax +31 20 4201152

FRUTAS E VEGETAIS

As imagens de frutas e vegetais são muito usadas como ilustrações para receitas, menus e livros de culinária, mas também para postais, convites e t-shirts. Estes conjuntos de livro e CD contêm reproduções de 250 fotografias de alta qualidade de frutas e vegetais, desde as espécies mais vulgares até às mais exóticas. As legendas multilingues valorizam as ilustrações e permitem a utilização do termo Dicionário Visual.

LIVRO E CD-ROM

Este livro contém imagens que podem ser utilizadas como recurso gráfico ou inspiração. Todas as ilustrações estão armazenadas no CD-ROM gratuito que acompanha o livro e estão prontas para serem utilizadas em materiais impressos de qualidade profissional e na concepção de páginas para a Web.

As imagens podem, também, ser utilizadas para criar postais, em papel ou digitais, ou para decorar cartas, panfletos, etc. Podem ser importadas directamente do CD para a maioria dos programas de desenho, manipulação de imagens, ilustração, processamento de texto e correio electrónico. Alguns programas permitem o acesso directo às imagens, ao passo que noutros é necessário criar primeiro um documento para, em seguida, importar para ele as imagens. Consulte o manual do software para obter instruções.

Os nomes dos ficheiros no CD-ROM correspondem aos números das páginas do livro. O CD-ROM é fornecido gratuitamente com este livro, mas não pode ser vendido separadamente. Os editores não assumem qualquer responsabilidade em caso de incompatibilidade do CD com o sistema operativo do utilizador.

A utilização de imagens individuais para aplicações não profissionais é gratuita. As imagens não podem ser utilizadas para nenhum tipo de aplicação comercial ou profissional, incluindo todo e qualquer tipo de publicação impressa ou digital, sem a prévia autorização da The Pepin Press/Agile Rabbit Editions.

Os ficheiros nos CD-ROMs da Pepin Press/Agile Rabbit são de alta qualidade e suficientemente grandes para a maioria das finalidades a que se destinam. Se necessário, é possível encomendar ficheiros maiores e/ou vectorizados da maioria das imagens à The Pepin Press/Agile Rabbit Editions.

Para obter esclarecimentos sobre autorizações e preços, contacte:
mail@pepinpress.com
Fax +31 20 4201152

アジャイレ・ラビット・ビジュアルフルーツ事典

フルーツと野菜のイメージは、レシピやメニュー、料理本のイラストとしてだけでなく、ハガキや招待状、Tシャツのイメージとしても人気があります。この本とCDのセットには、身近なものから非常に珍しい種類まで、フルーツと野菜の高画質の写真、250点が収録されています。

本とCD-ROM

この本に掲載されているイメージは、グラフィック用として、また参考用として使用することができます。
掲載されている全イラストは、付録のCD-ROMに高解像で収録されており、プロ・レベルの印刷媒体やウェブ・デザインに使用できます。

また、ハガキや手紙、チラシのイメージとしても使えます。プログラムによっては、直接イメージにアクセスできます。そうでない場合には、ファイルを作成し、イメージをインポートしてください。方法については、お手元のソフトウエアのマニュアルでご確認ください。

CD-ROMの各ファイル名は、この本のページ番号と同じです。CD-ROM は付録ですが、本と別売りではありません。このCDがお使いのシステムと互換性がない場合には、当社は責任を負いません。

ビジネス目的で使用しない場合には、イメージの1回の使用には使用料はかかりません。商業目的や、ビジネスを目的で使用する場合には(すべての種類の印刷物への使用、デジタル使用を含みます)ザ・ペピン・プレス／アジャイレ・ラビット・エディションズから、事前の許可を得ることが必要です。

ペピン・プレス／アジャイレ・ラビットのCD-ROMは高品質で、ほとんどのアプリケーションに十分なサイズです。もっと大きなサイズのファイル、あるいはベクトル化したファイルについては、ザ・ペピン・プレス／アジャイレ・ラビット・エディションズあてにご注文ください。

使用許可と使用料については、下記までお問い合わせください。
Eメール：mail@pepinpress.com
ファクス: +31 20 4201152

Agile Rabbit可视水果词典

水果和蔬菜图像不但流行于用作菜谱、菜单和食谱的插图，也适用于用作明信片、请柬和T恤衫的插图。这些图书和光盘包括250幅高质量水果和蔬菜照片的复制品，包括普通水果蔬菜到罕见的外国品种。

图书和光盘

本书中的图片可用于绘图和创作。所有插图均以高清晰度的格式储存于所附的免费光盘中，可用于专业印刷媒体以及网页设计。

这些图片也可用于制作明信片，无论是纸质还是数码，或装饰您的信函和传单等。这些图片可以直接从光盘中输出到大部分的设计、图像处理、插图、文字处理以及电子邮件程序中。有些程序允许您直接获得图片；有些程序需要您首先建立一个文件然后输入图片。请参阅您的软件说明手册。

光盘上的文件名称同本书的页码对应。光盘随本书免费赠送，但不单独销售。如果光盘同您的系统不相容，出版商不承担任何责任。

对于非专业应用，单个图像免费使用。未经 Pepin Press/Agile Rabbit Editions 的事先允许，这些图片不得用于任何商业性或专业用途一包括所有类型的纸质或数字出版物。

Pepin Press/Agile Rabbit光盘上的文件质量可靠，对于大部分应用都足够大。但是，大部分图像的更大和/或向量化文件可以向Pepin 出版社/Agile Rabbit订购。

有关许可权和费用咨询，请联系:
mail@pepinpress.com
传真 +31 20 4201152

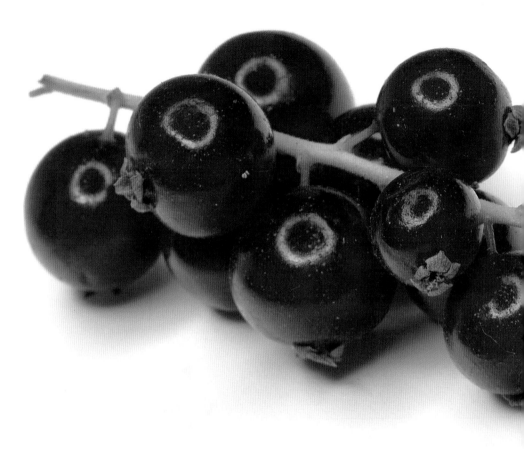

12-1

redcurrant
grosella roja
rote Johannisbeere
groseille rouge
ribes

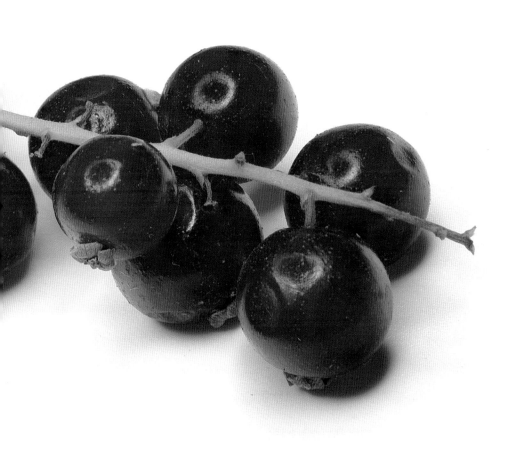

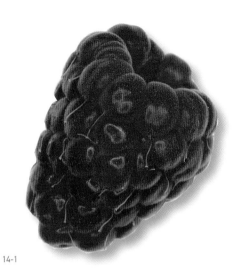

14-1

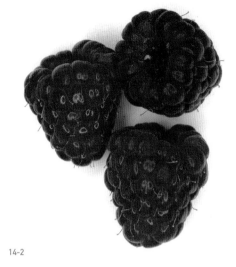

14-2

14-2

14-1	14-2	14-3
raspberry	raspberry	wild strawberries
frambuesa	frambuesa	fresas silvestres
Himbeere	Himbeere	Walderdbeeren
framboise	framboise	fraises des bois
lampone	lampone	fragole di bosco

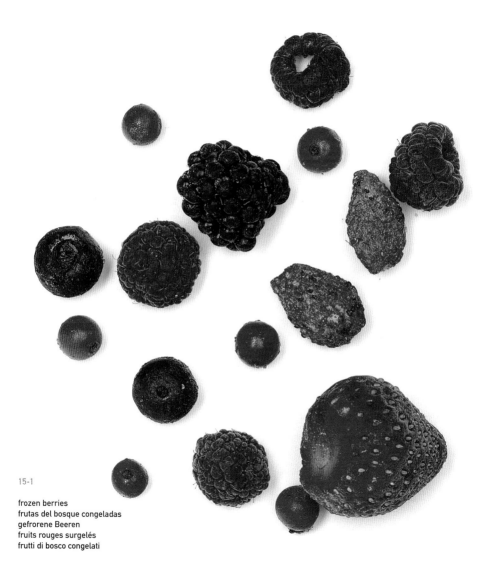

15-1

frozen berries
frutas del bosque congeladas
gefrorene Beeren
fruits rouges surgelés
frutti di bosco congelati

16-1

strawberry
fresón
Erdbeere
fraise
fragola

17-1

strawberry
fresón
Erdbeere
fraise
fragola

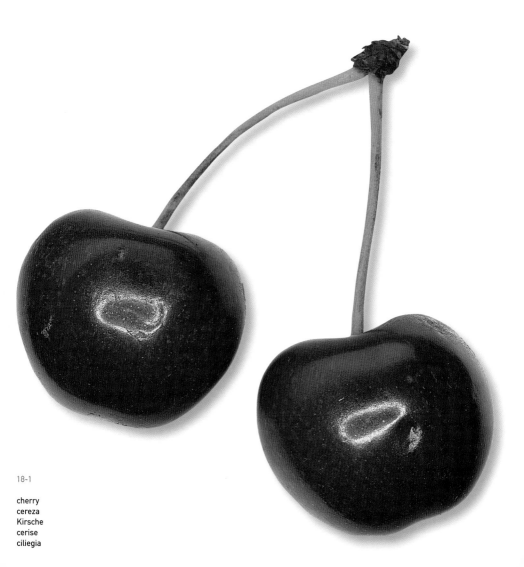

18-1

cherry
cereza
Kirsche
cerise
ciliegia

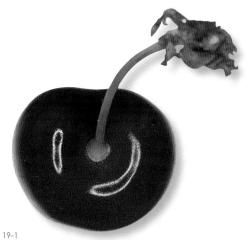

19-1

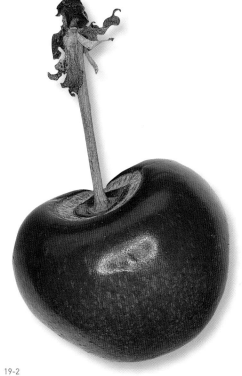

19-1

cherry
cereza
Kirsche
cerise
ciliegia

19-2

cherry
cereza
Kirsche
cerise
ciliegia

19-2

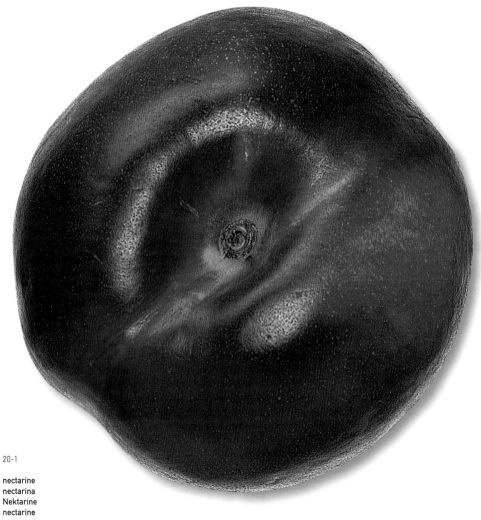

20-1

nectarine
nectarina
Nektarine
nectarine
pesca noce

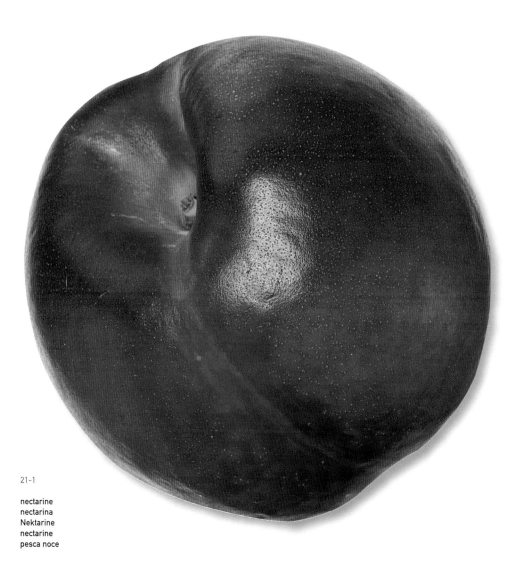

21-1

nectarine
nectarina
Nektarine
nectarine
pesca noce

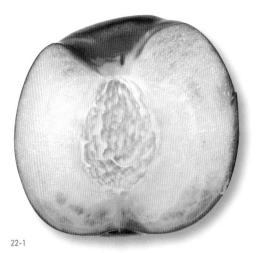

22-1

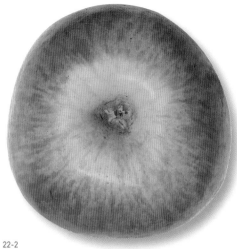

22-2

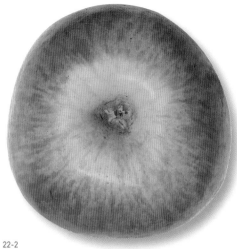

22-3

22-1	22-2	22-3
peach	Red Delicious apple	Fuji apple
melocotón	manzana roja	manzana fuji
Pfirsich	roter Delicious-Apfel	Fuji-Apfel
pêche	pomme Red Delicious	pomme fuji
pesca	mela Red Delicious	mela fuji

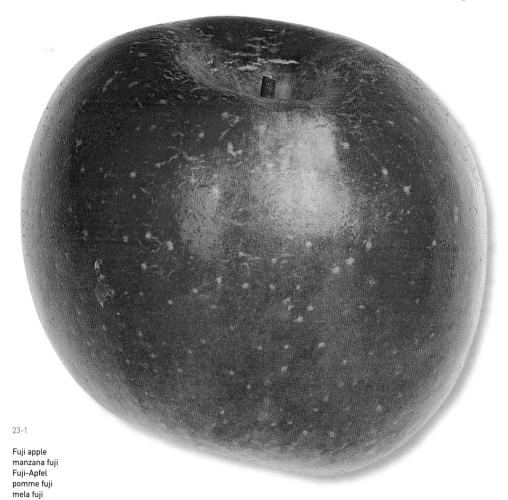

23-1

Fuji apple
manzana fuji
Fuji-Apfel
pomme fuji
mela fuji

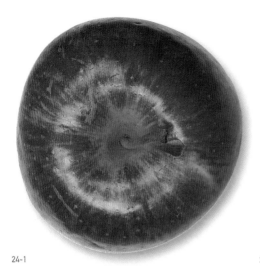

24-1

24-2

24-2

24-1	24-2	24-3
Starking apple	Starking apple	Starking apple
manzana Starking	manzana Starking	manzana Starking
Starking-Apfel	Starking-Apfel	Starking-Apfel
pomme Starking	pomme Starking	pomme Starking
mela Starking	mela Starking	mela Starking

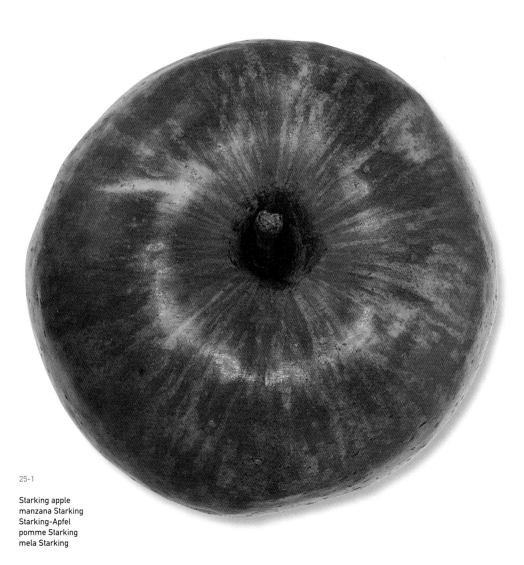

25-1

Starking apple
manzana Starking
Starking-Apfel
pomme Starking
mela Starking

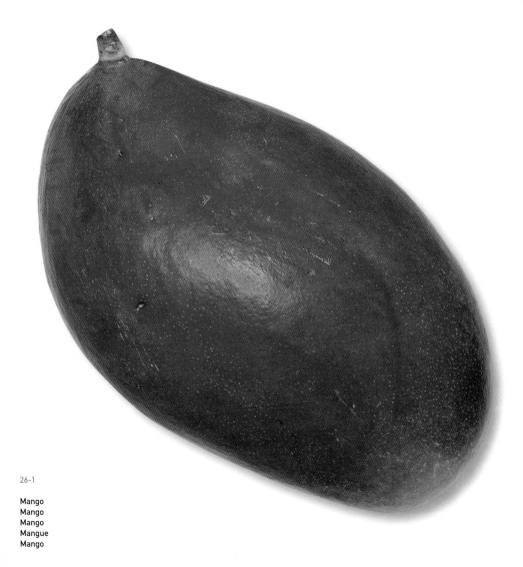

26-1

Mango
Mango
Mango
Mangue
Mango

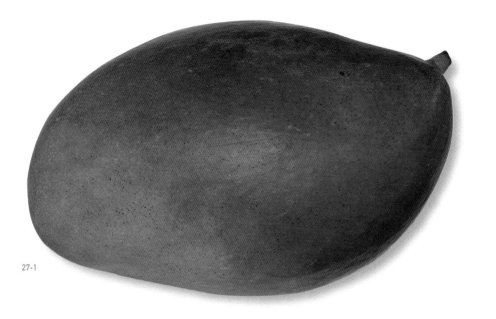

27-1

27-1

Mango
Mango
Mango
Mangue
Mango

27-2

Mango
Mango
Mango
Mangue
Mango

27-2

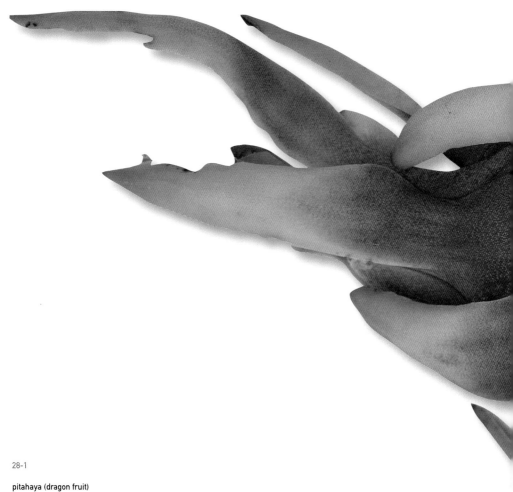

28-1

pitahaya (dragon fruit)
pitahaya (fruta del dragón)
Pitahaya (Drachenfrucht)
pitaya (fruit du dragon)
pitahaya (frutto del dragone)

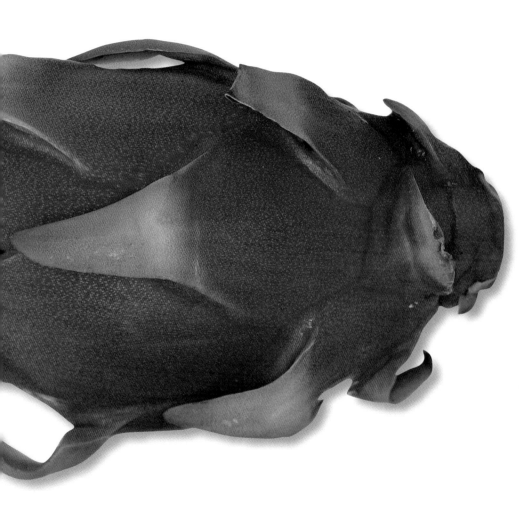

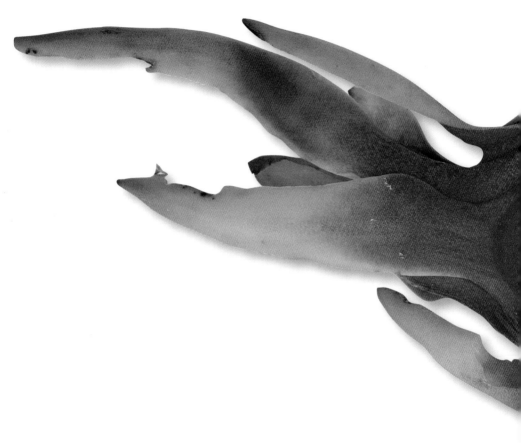

pitahaya (dragon fruit)
pitahaya (fruta del dragón)
Pitahaya (Drachenfrucht)
pitaya (fruit du dragon)
pitahaya (frutto del dragone)

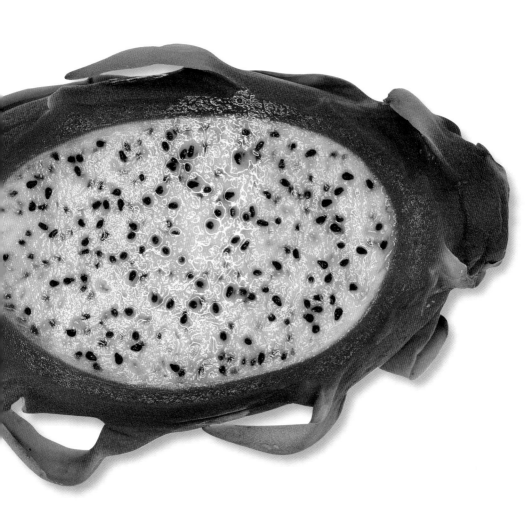

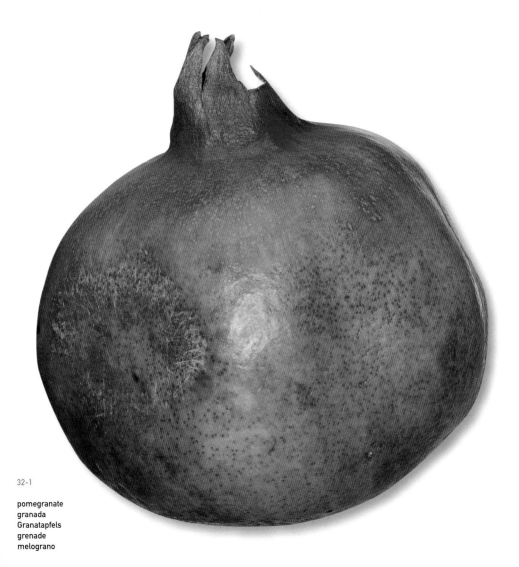

32-1

pomegranate
granada
Granatapfels
grenade
melograno

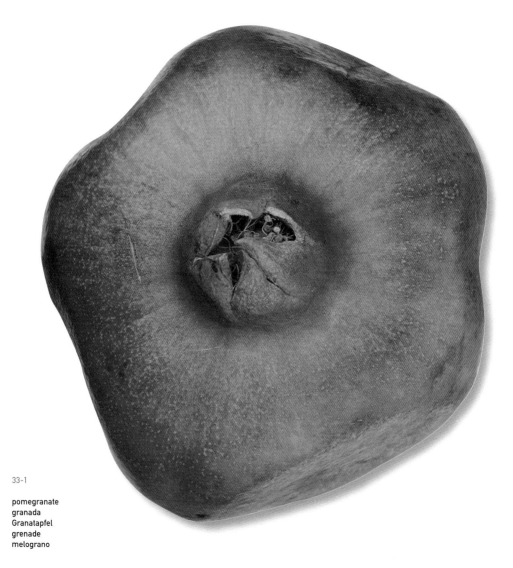

33-1

pomegranate
granada
Granatapfel
grenade
melograno

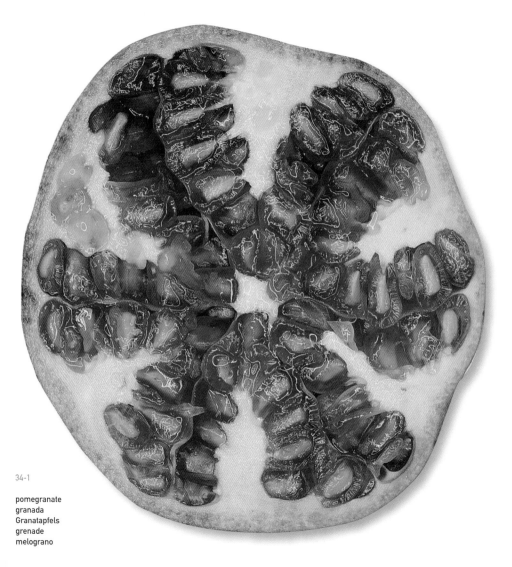

34-1

pomegranate
granada
Granatapfels
grenade
melograno

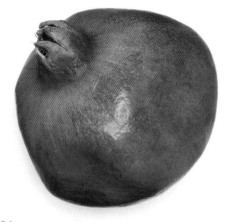

35-1

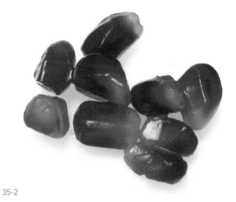

35-2

35-3

35-1	35-2	35-3
pomegranate	pomegranate	rambutan
granada	granada	rambután
Granatapfel	Granatapfel	Rambutan
grenade	grenade	ramboutan
melograno	melograno	ramboutan

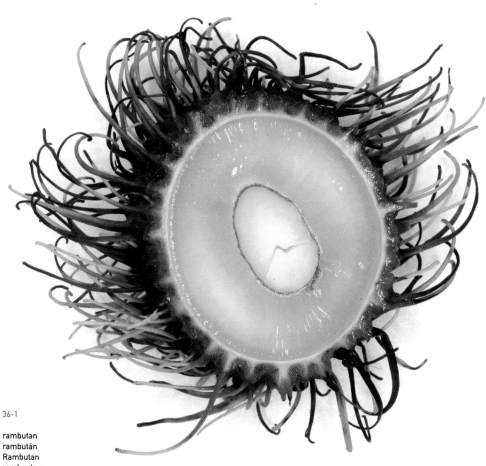

36-1

rambutan
rambután
Rambutan
ramboutan
ramboutan

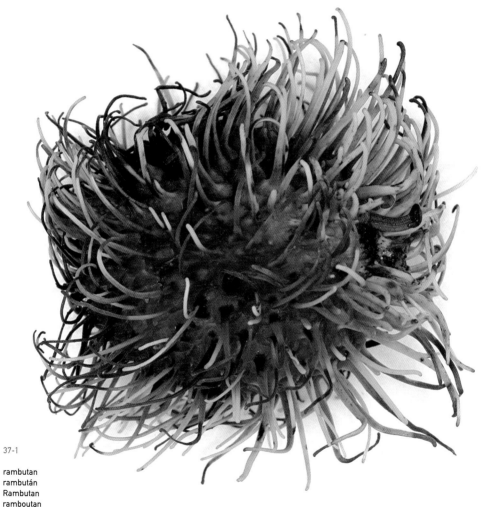

rambutan
rambután
Rambutan
ramboutan
ramboutan

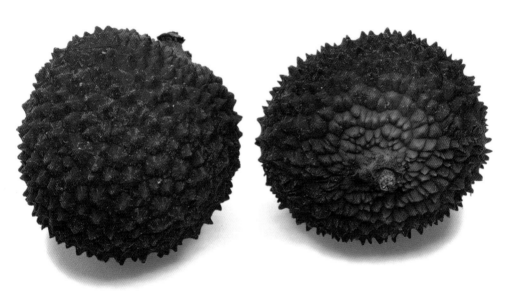

38-1

lychee
lichi
Litschi
litchi
litchi

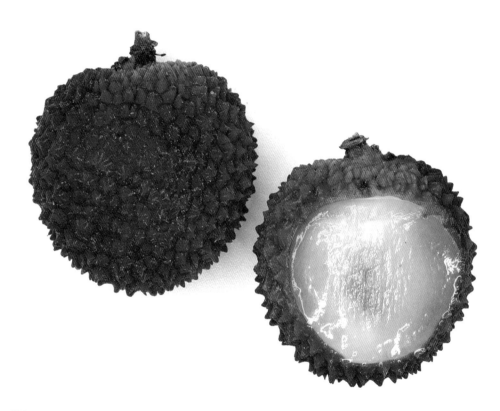

39-1

lychee
lichi
Litschi
litchi
litchi

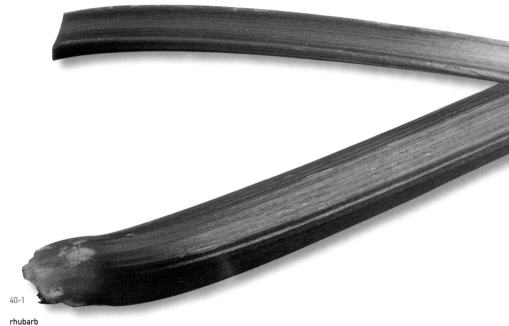

40-1

rhubarb
ruibarbo
Rhabarber
rhubarbe
rabarbarob

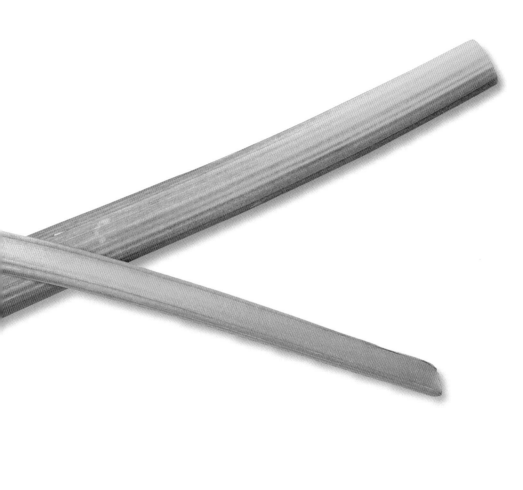

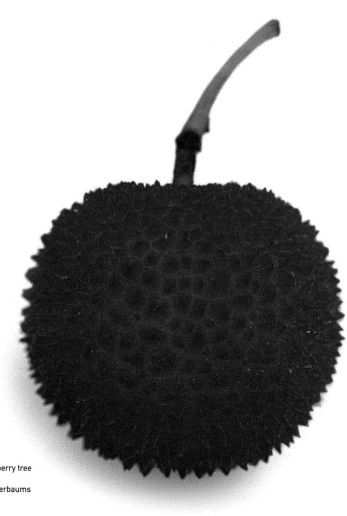

42-1

fruit of the strawberry tree
madroño
Frucht des Erdbeerbaums
arbouse
corbezzolo

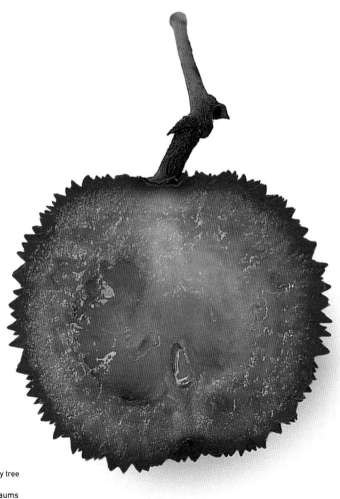

43-1

fruit of the strawberry tree
madroño
Frucht des Erdbeerbaums
arbouse
corbezzolo

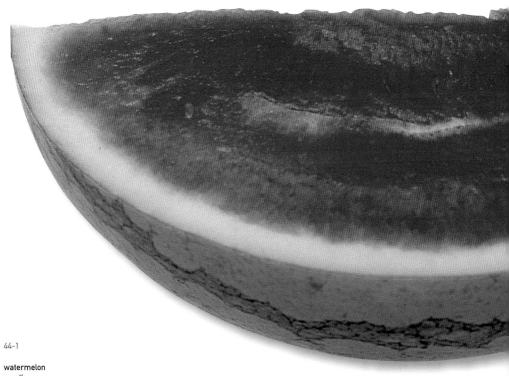

44-1

watermelon
sandía
Wassermelone
pastèque
anguria

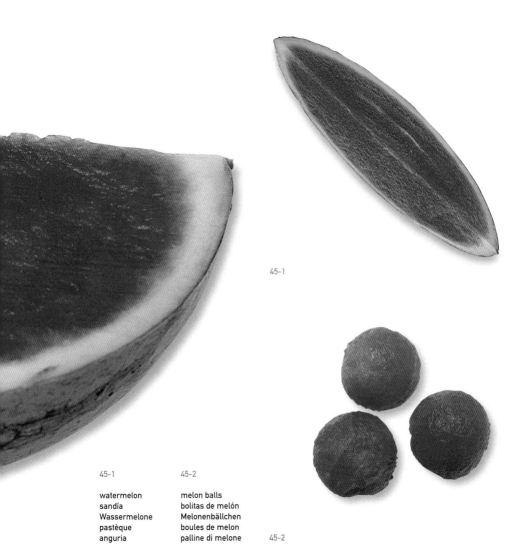

45-1

45-1　　　　45-2

watermelon　　melon balls
sandía　　　　bolitas de melón
Wassermelone　Melonenbällchen
pastèque　　　boules de melon
anguria　　　　palline di melone

45-2

46-1

pistachios
pistachos
Pistazien
pistaches
pistacchi

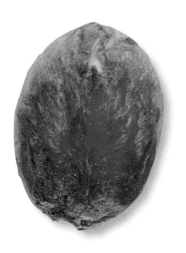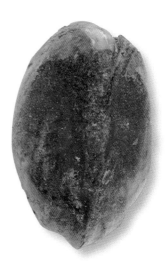

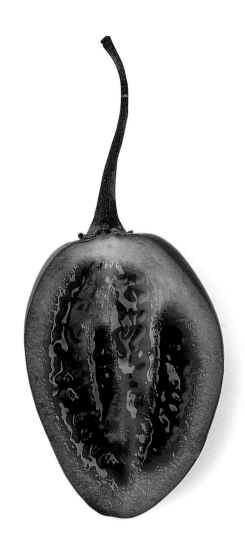

48-1

tree tomato
tomate de árbol
Baumtomate
tomate d´arbre
pomodoro arboreo

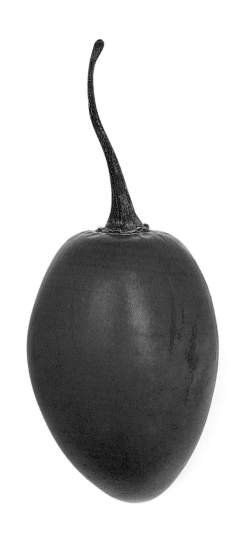

49-1

tree tomato
tomate de árbol
Baumtomate
tomate d´arbre
pomodoro arboreo

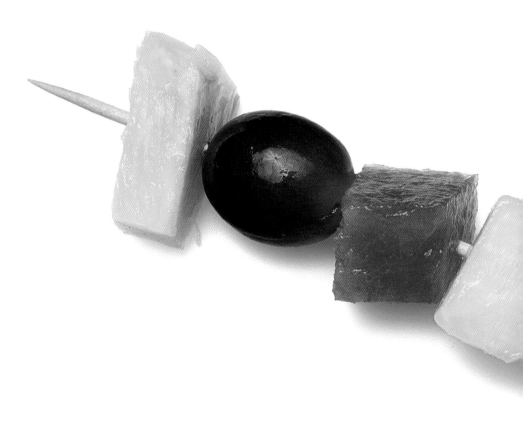

50-1

fruit kebab
brocheta de frutas
Früchtespieß
brochette de fruits
spiedino di frutta

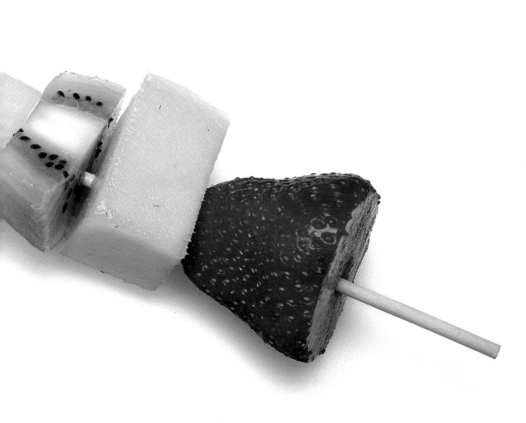

physalis
alquequenje
Physalis
physalis
alchechengi

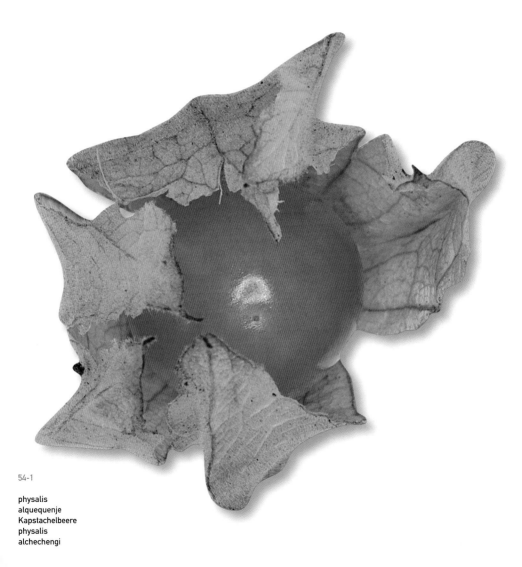

54-1

physalis
alquequenje
Kapstachelbeere
physalis
alchechengi

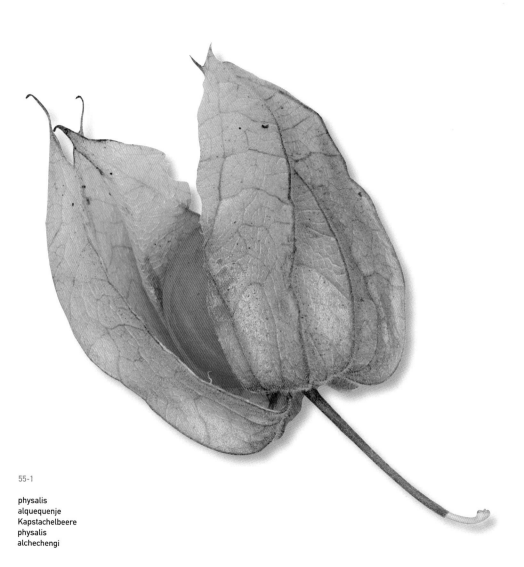

55-1

physalis
alquequenje
Kapstachelbeere
physalis
alchechengi

56-1

prickly pear
higo chumbo
Kaktusfeige
figue de Barbarie
fico d'India

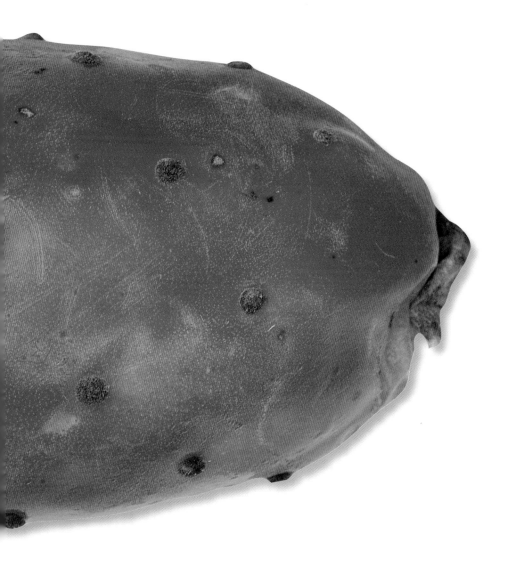

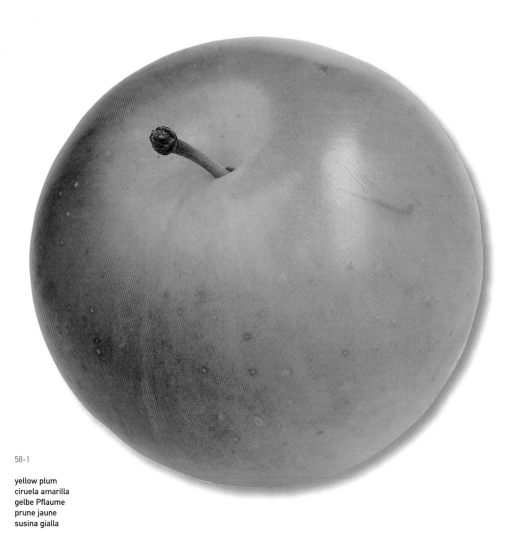

58-1

yellow plum
ciruela amarilla
gelbe Pflaume
prune jaune
susina gialla

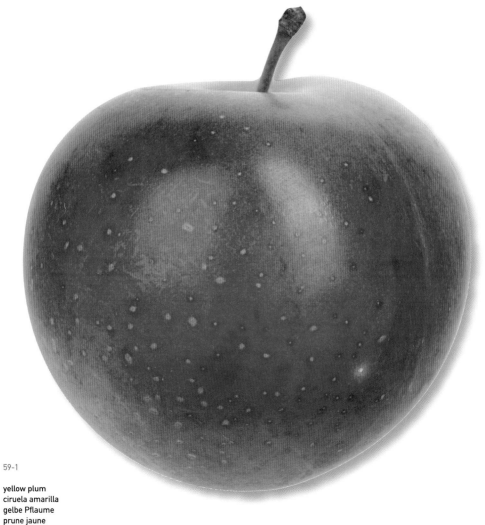

59-1

yellow plum
ciruela amarilla
gelbe Pflaume
prune jaune
susina gialla

60-1

60-2

60-3

60-1	60-2	60-3
yellow plum	nectarine	nectarine
ciruela amarilla	nectarina	nectarina
gelbe Pflaume	Nektarine	Nektarine
prune jaune	nectarine	nectarine
susina gialla	pesca noce	pesca noce

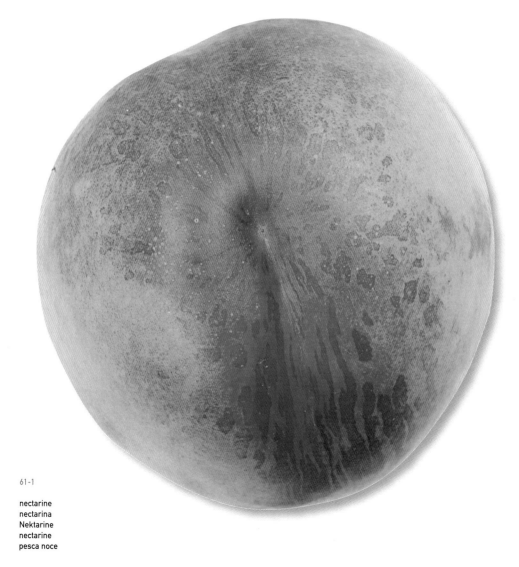

61-1

nectarine
nectarina
Nektarine
nectarine
pesca noce

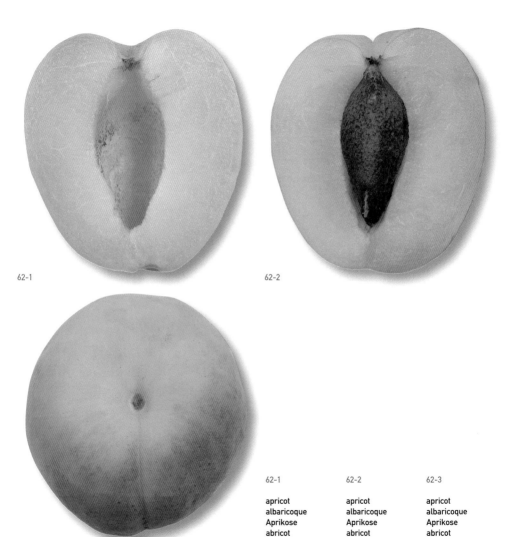

62-1

62-2

62-3

62-1	62-2	62-3
apricot	apricot	apricot
albaricoque	albaricoque	albaricoque
Aprikose	Aprikose	Aprikose
abricot	abricot	abricot
albicocca	albicocca	albicocca

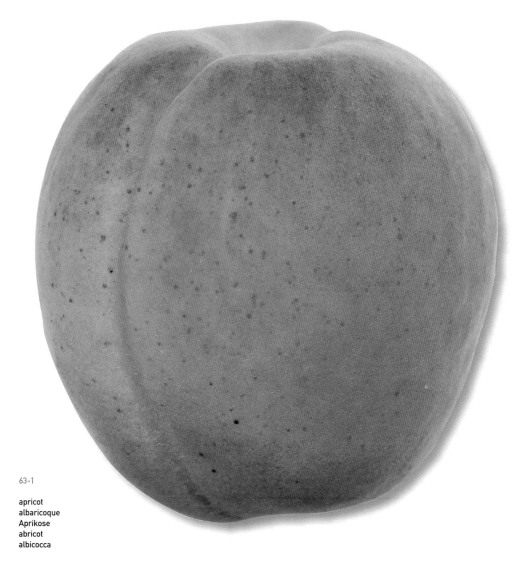

63-1

apricot
albaricoque
Aprikose
abricot
albicocca

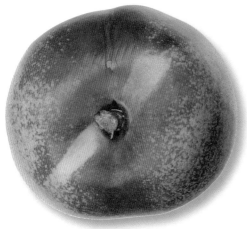

64-1

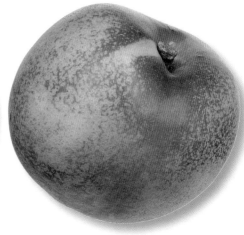

64-2

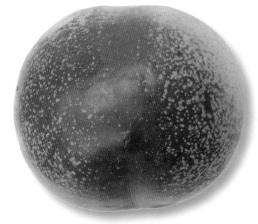

64-3

64-1	64-2	64-3
nectarine	nectarine	nectarine
nectarina	nectarina	nectarina
Nektarine	Nektarine	Nektarine
nectarine	nectarine	nectarine
pesca noce	pesca noce	pesca noce

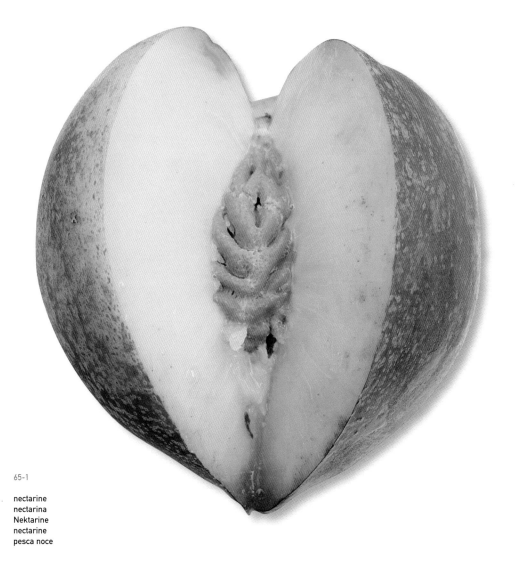

65-1

nectarine
nectarina
Nektarine
nectarine
pesca noce

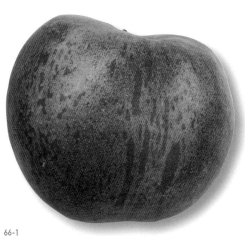

66-1

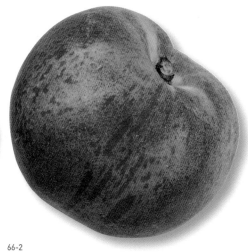

66-2

66-3

66-1	66-2	66-3
peach	peach	peach
melocotón viña	melocotón viña	melocotón viña
Pfirsich	Pfirsich	Pfirsich
pêche	pêche	pêche
pesca	pesca	pesca

67-1

dried apricots
orejones de albaricoque
getrocknete Aprikosen
abricots secs
albicocche disidratate

68-1

68-2

68-3

68-1	68-2	68-3
yellow plum	yellow plum	crystallised orange
ciruela amarilla	ciruela amarilla	naranja confitada
gelbe Pflaume	gelben Pflaume	kandierte Orange
prune jaune	prune jaune	orange confite
susina gialla	susina gialla	arancia confettata

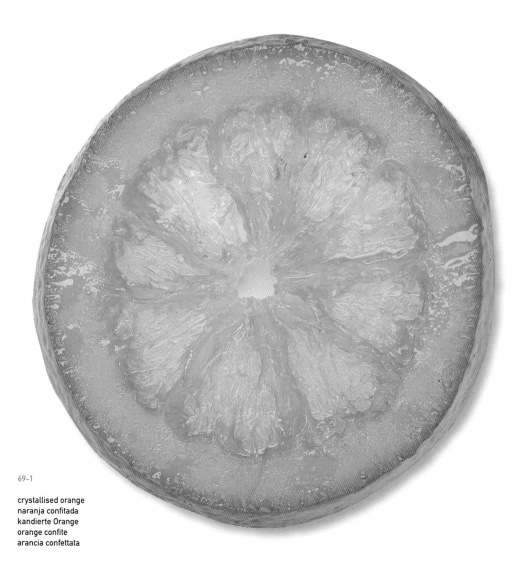

69-1

crystallised orange
naranja confitada
kandierte Orange
orange confite
arancia confettata

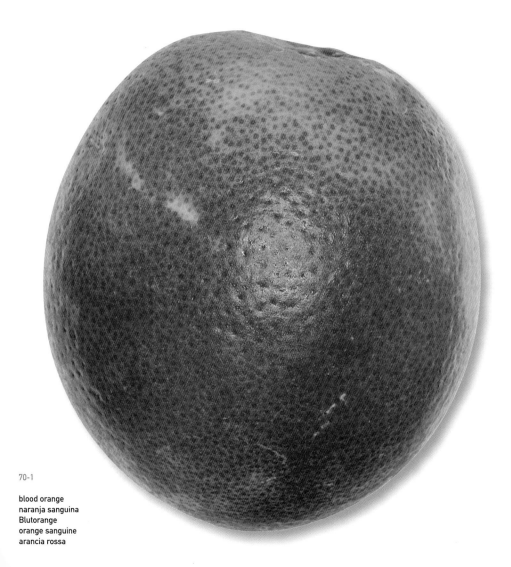

70-1

blood orange
naranja sanguina
Blutorange
orange sanguine
arancia rossa

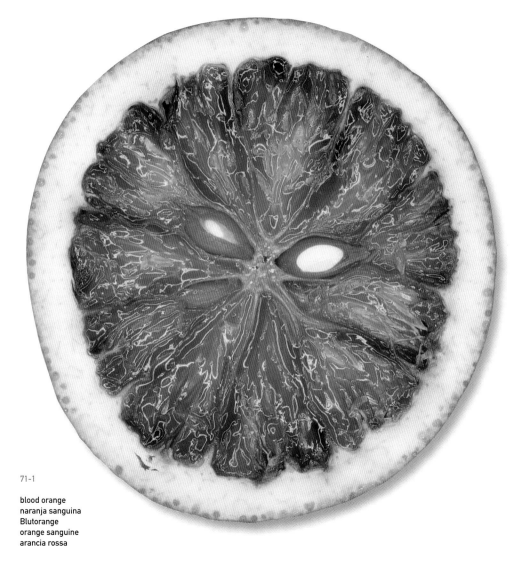

71-1

blood orange
naranja sanguina
Blutorange
orange sanguine
arancia rossa

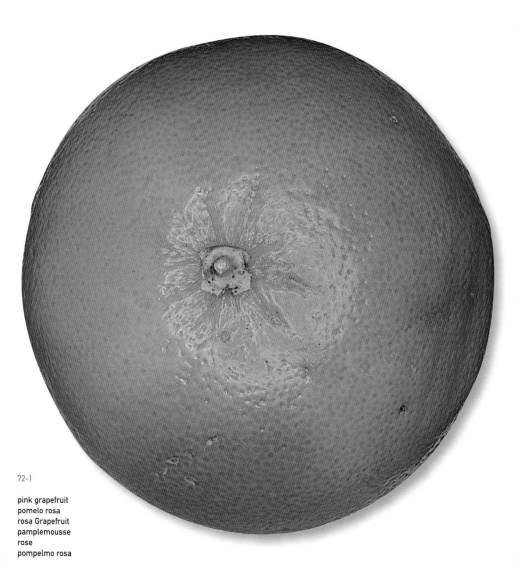

72-1

pink grapefruit
pomelo rosa
rosa Grapefruit
pamplemousse
rose
pompelmo rosa

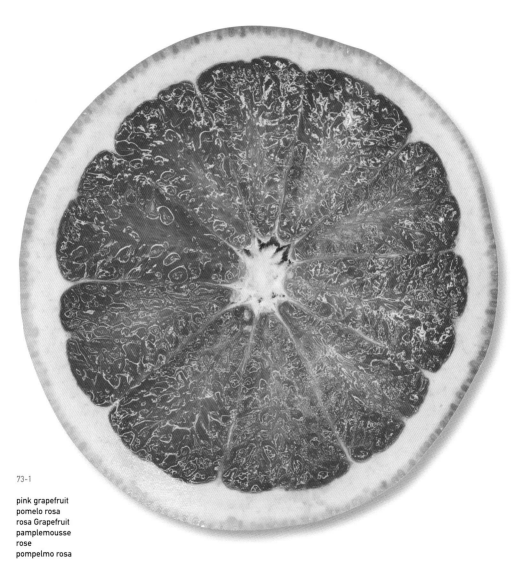

73-1

pink grapefruit
pomelo rosa
rosa Grapefruit
pamplemousse
rose
pompelmo rosa

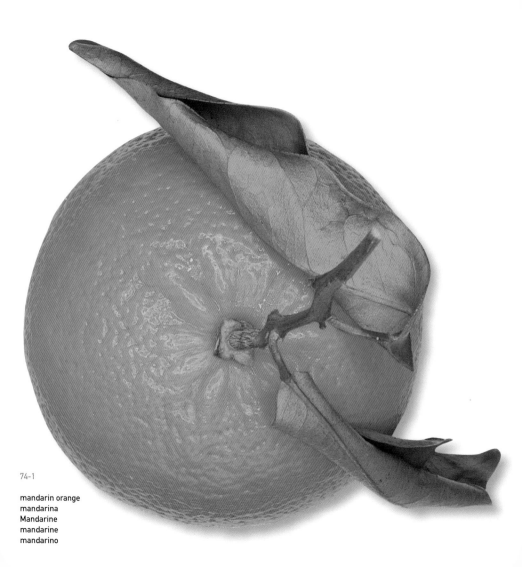

74-1

mandarin orange
mandarina
Mandarine
mandarine
mandarino

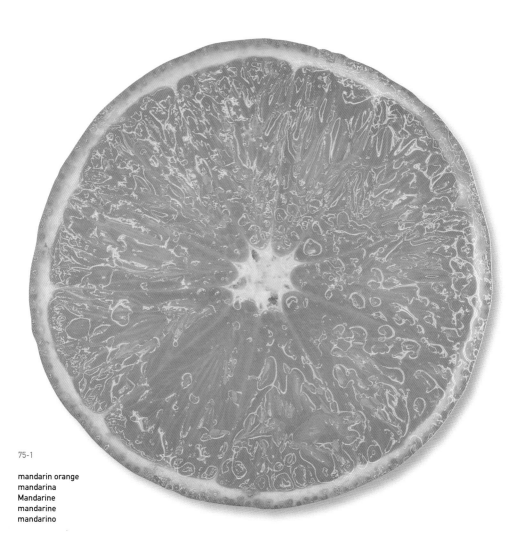

75-1

mandarin orange
mandarina
Mandarine
mandarine
mandarino

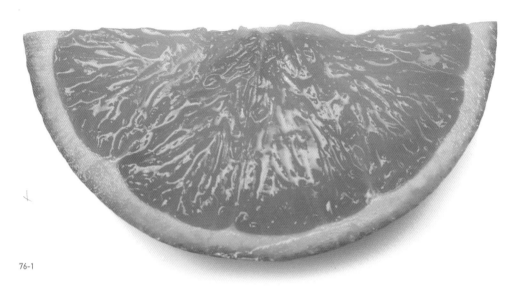

76-1

76-2

76-1	76-2
orange	orange
naranja	naranja
Orange	Orange
orange	orange
arancia	arancia

77-1

77-2

77-3

77-1	77-2	77-3
orange	orange	orange
naranja	naranja	naranja
Orange	Orange	Orange
orange	orange	orange
arancia	arancia	arancia

78-1

kumquat
kumquat
Kumquat
kumquat
mandarino cinese

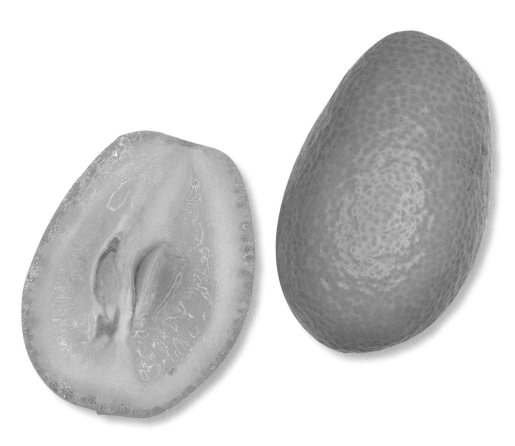

79-1

kumquat
kumquat
Kumquat
kumquat
mandarino cinese

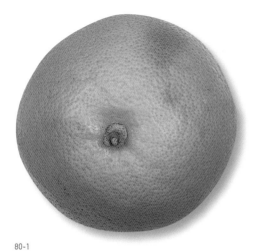

80-1

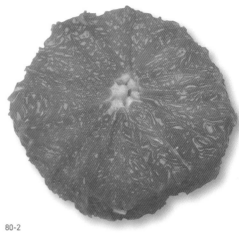

80-2

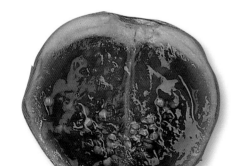

80-3

80-1	80-2	80-3
pink grapefruit	pink grapefruit	naranjilla (lulo)
pomelo rosa	pomelo rosa	naranjilla (lulo)
rosa Grapefruit	rosa Grapefruit	Naranjilla (Lulo)
pamplemousse rose	pamplemousse rose	naranjilla (lulo)
pompelmo rosa	pompelmo rosa	naranjilla

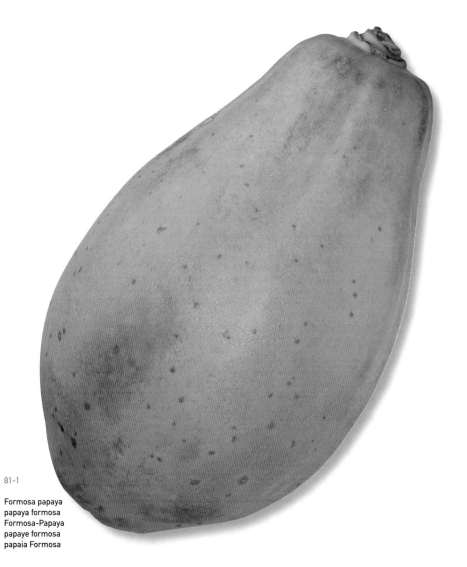

81-1

Formosa papaya
papaya formosa
Formosa-Papaya
papaye formosa
papaia Formosa

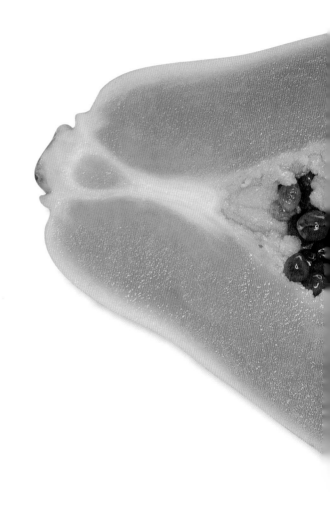

Formosa papaya
papaya formosa
Formosa-Papaya
papaye formosa
papaia Formosa

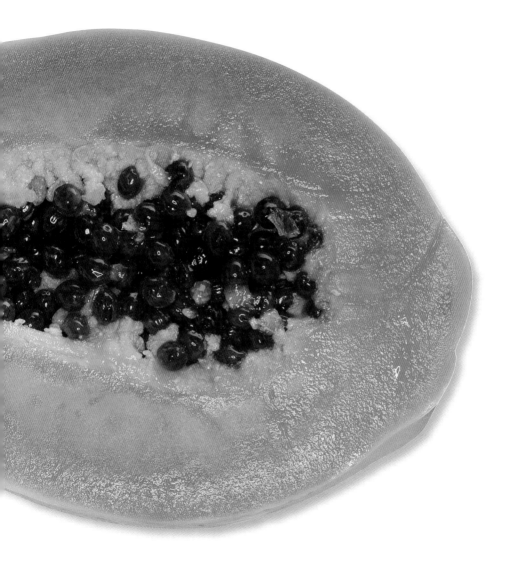

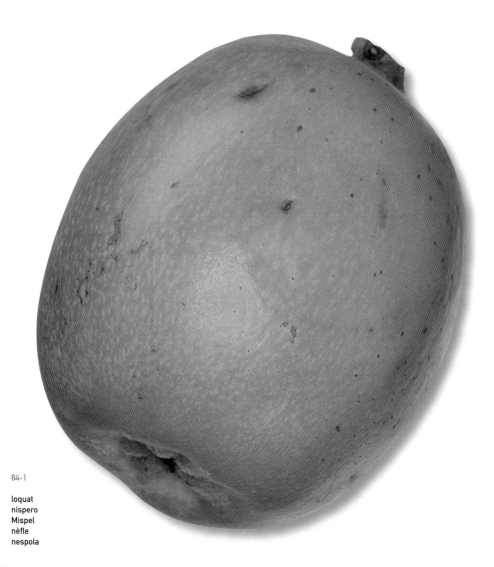

84-1

loquat
níspero
Mispel
nèfle
nespola

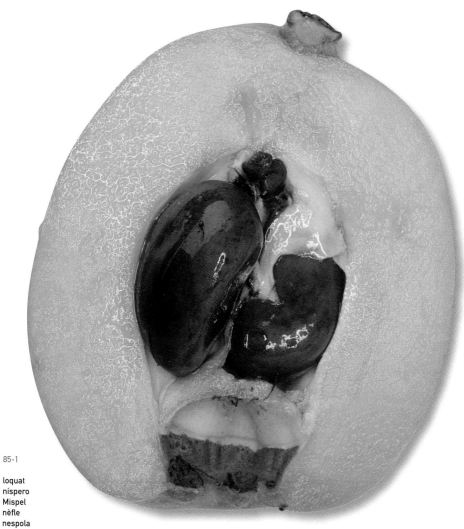

85-1

loquat
níspero
Mispel
nèfle
nespola

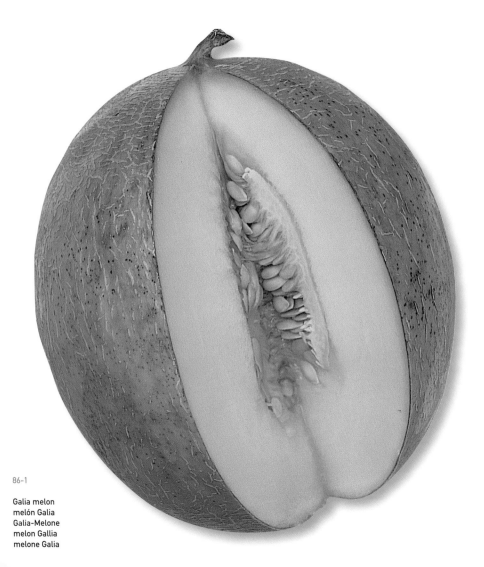

86-1

Galia melon
melón Galia
Galia-Melone
melon Gallia
melone Galia

Galia melon
melón Galia
Galia-Melone
melon Gallia
melone Galia

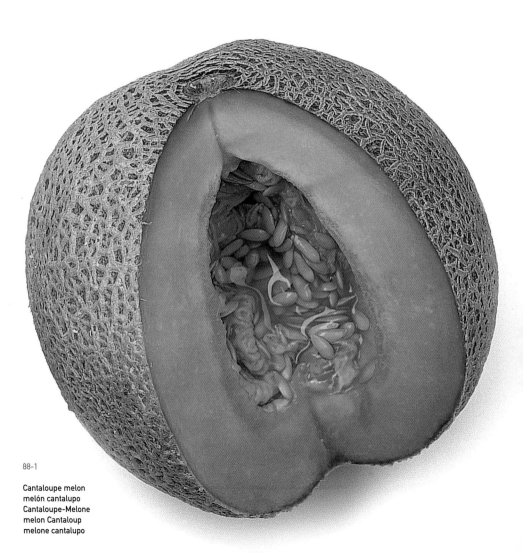

88-1

Cantaloupe melon
melón cantalupo
Cantaloupe-Melone
melon Cantaloup
melone cantalupo

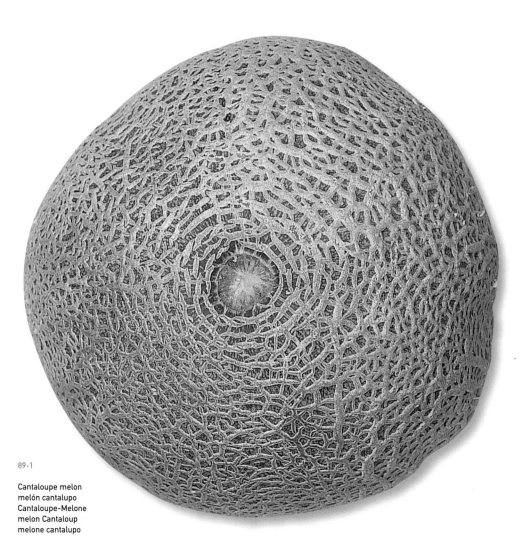

89-1

Cantaloupe melon
melón cantalupo
Cantaloupe-Melone
melon Cantaloup
melone cantalupo

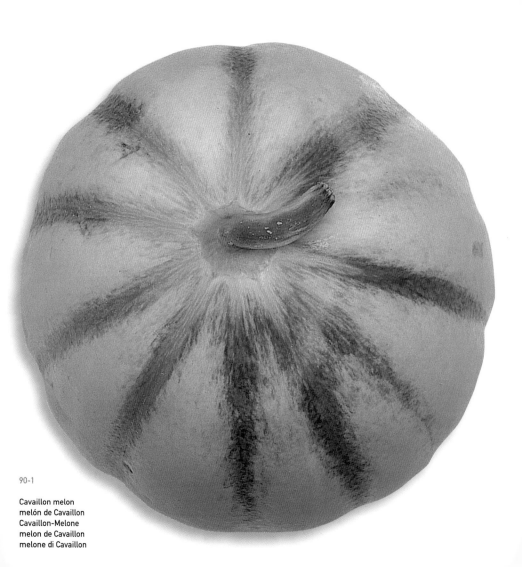

90-1

Cavaillon melon
melón de Cavaillon
Cavaillon-Melone
melon de Cavaillon
melone di Cavaillon

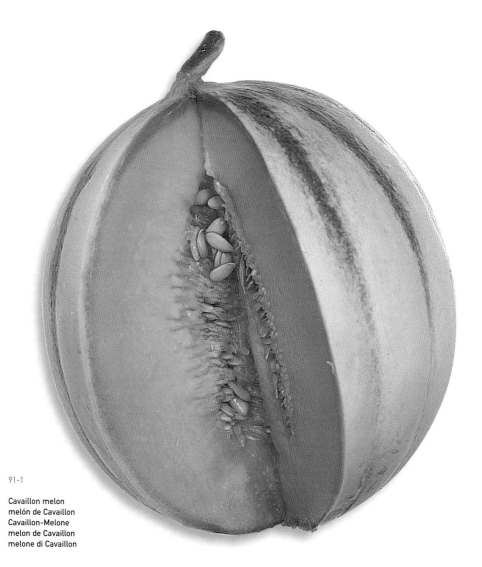

91-1

Cavaillon melon
melón de Cavaillon
Cavaillon-Melone
melon de Cavaillon
melone di Cavaillon

92-1

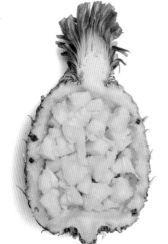

92-3

92-2

92-1	92-2	92-3
baby pineapple	pineapple	pineapple
piña baby	piña	piña
Mini-Ananas	Ananas	Ananas
ananas miniature	ananas	ananas
ananas baby	ananas	ananas

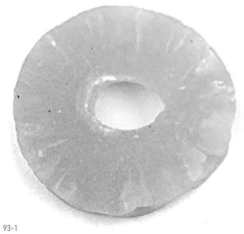

93-1

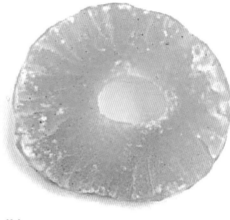

93-2

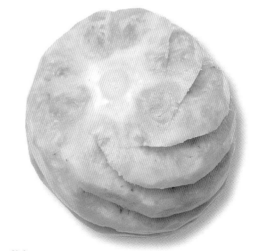

93-3

93-1, 93-3

crystallised pineapple
piña confitada
kandierte Ananas
ananas confit
ananas candita

93-3

pineapple
piña
Ananas
ananas
ananas

93-3

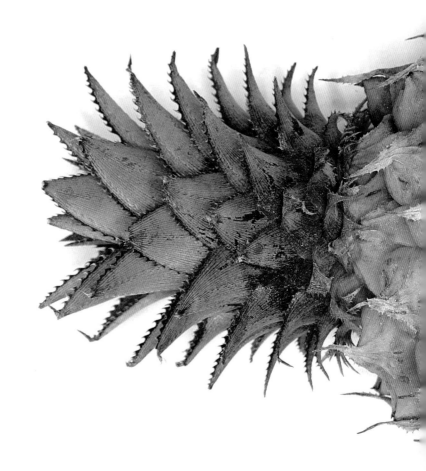

94-1

pineapple
piña americana
Ananas
ananas américain
ananas

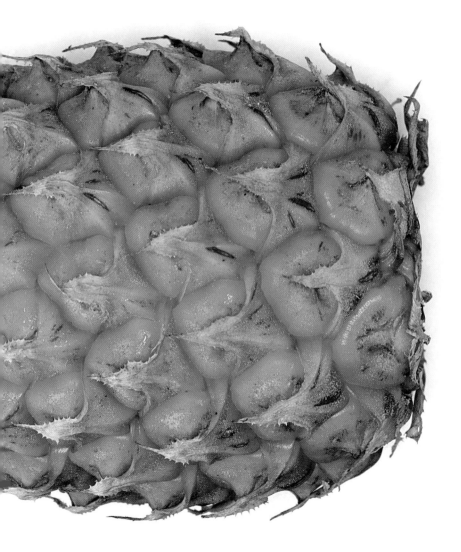

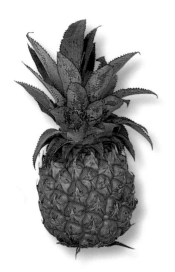

96-1

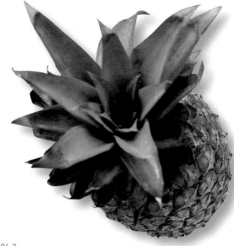

96-2

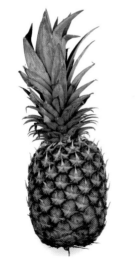

96-2

96-1	96-2	96-3
baby pineapple	pineapple	pineapple
piña baby	piña americana	piña americana
Mini-Ananas	Ananas	Ananas
ananas miniature	ananas américain	ananas américain
ananas baby	ananas	ananas

97-1

97-1

melon balls
bolitas de melón
Melonenbällchen
boules de melon
palline di melone

97-2

yellow watermelon
sandía amarilla
gelbe Wassermelone
pastèque jaune
anguria gialla

97-2

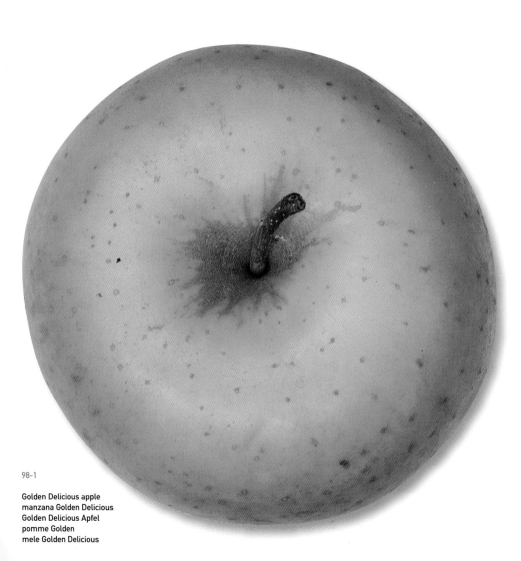

98-1

Golden Delicious apple
manzana Golden Delicious
Golden Delicious Apfel
pomme Golden
mele Golden Delicious

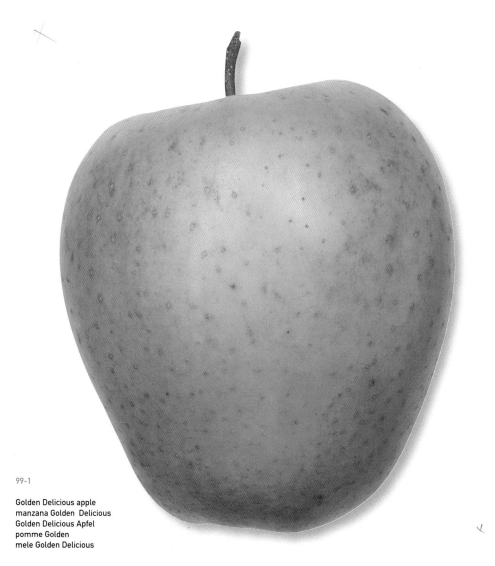

99-1

Golden Delicious apple
manzana Golden Delicious
Golden Delicious Apfel
pomme Golden
mele Golden Delicious

100-1

100-2

100-2

100-1	100-2	100-3
apple	apple	apple
manzana	manzana	manzana
Apfel	Apfel	Apfel
pomme	pomme	pomme
mela	mela	mela

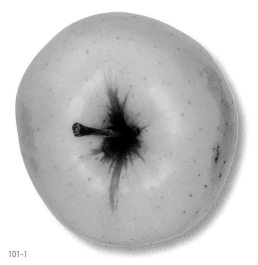

101-1

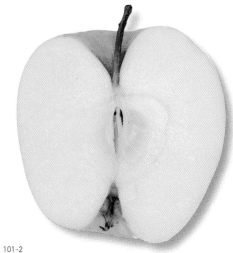

101-2

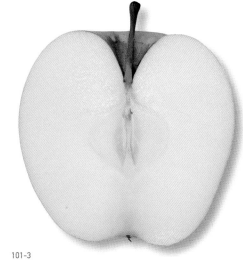

101-3

101-1	101-2	101-3
apple	apple	apple
manzana	manzana	manzana
Apfel	Apfel	Apfel
pomme	pomme	pomme
mela	mela	mela

102-1

apple
manzana
Apfel
pomme
mela

103-1

apple
manzana
Apfel
pomme
mela

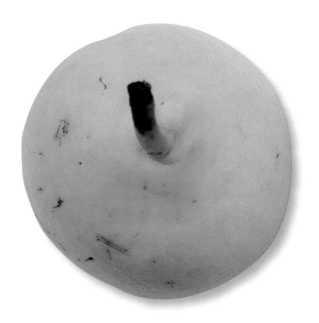

104-1

San Juan pear
pera de San Juan
Zuckerbirne
poire de la Saint Jean
pera di San Juan

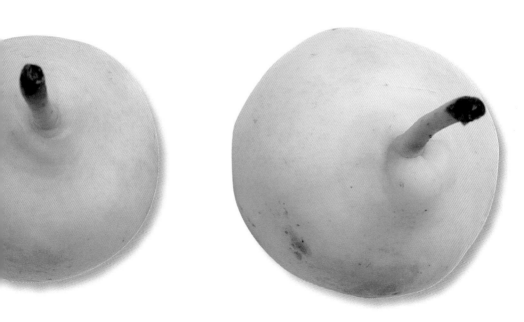

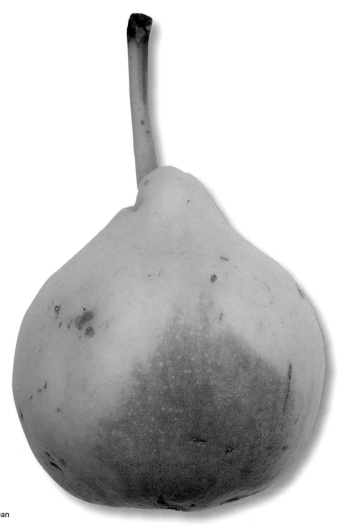

106-1

San Juan pear
pera de San Juan
Zuckerbirne
poire de la Saint Jean
pera di San Juan

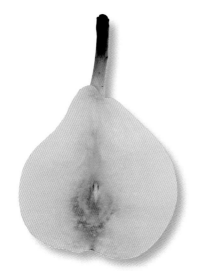

107-1

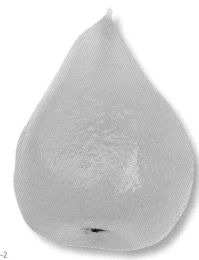

107-2

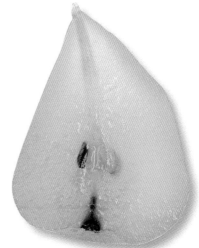

107-3

107-1	107-2	107-3
San Juan pear, pera de San Juan Zuckerbirne poire de la Saint Jean pera di San Juan	crystallised pear pera confitada kandierte Birne poire confite pera confettata	crystallised pear pera confitada kandierte Birne poire confite pera confettata

108-1

lemon
limón
Zitrone
citron
limone

110-1

lemon
limón
Zitrone
citron
limone

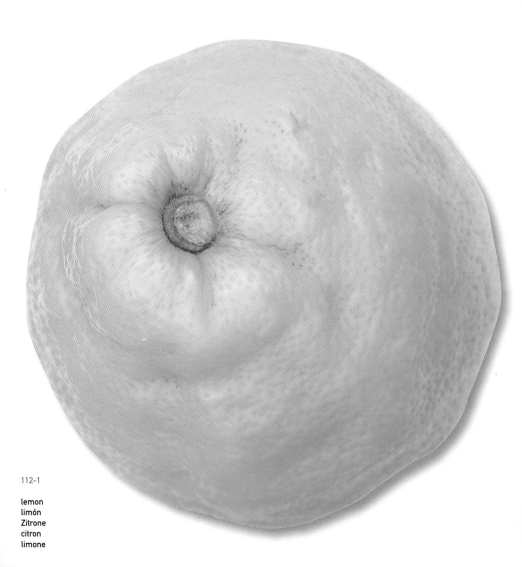

112-1

lemon
limón
Zitrone
citron
limone

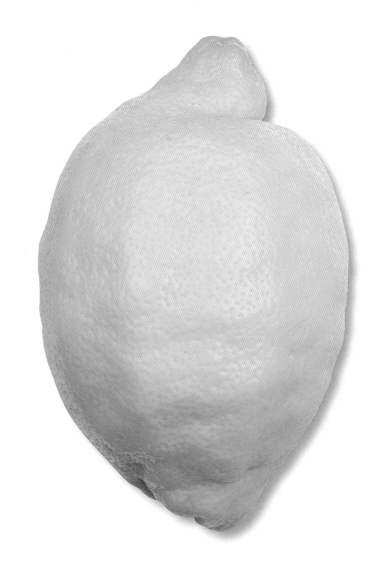

113-1

lemon
limón
Zitrone
citron
limone

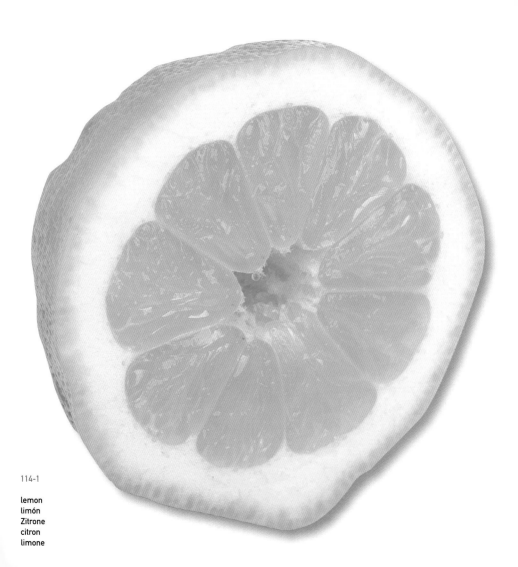

114-1

lemon
limón
Zitrone
citron
limone

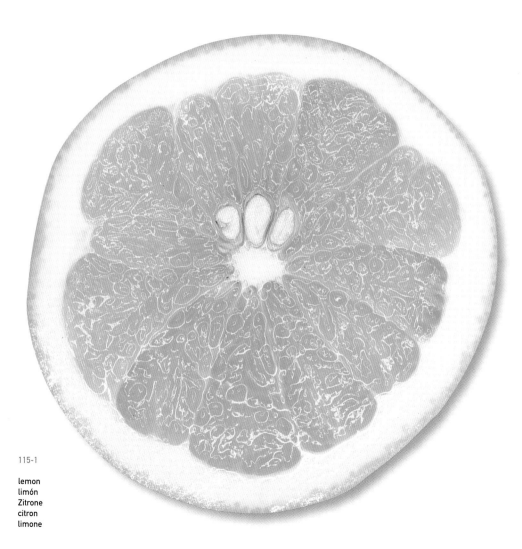

115-1

lemon
limón
Zitrone
citron
limone

116-1

lemon
limón
Zitrone
citron
limone

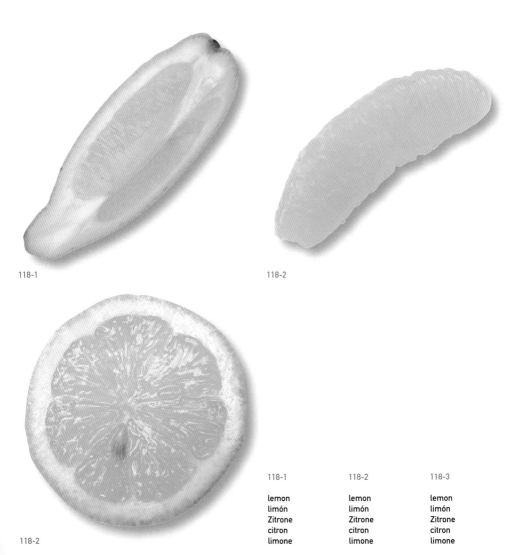

118-1

118-2

118-2

118-1	118-2	118-3
lemon	lemon	lemon
limón	limón	limón
Zitrone	Zitrone	Zitrone
citron	citron	citron
limone	limone	limone

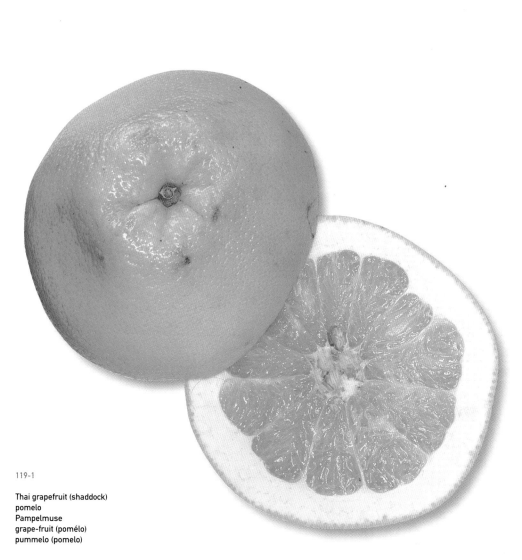

119-1

Thai grapefruit (shaddock)
pomelo
Pampelmuse
grape-fruit (pomélo)
pummelo (pomelo)

120-1

Thai grapefruit (shaddock)
pomelo
Pampelmuse
grape-fruit (pomélo)
pummelo (pomelo)

121-1

Thai grapefruit (shaddock)
pomelo
Pampelmuse
grape-fruit (pomélo)
pummelo (pomelo)

122-1

yellow melon
melón amarillo
gelbe Melone
melon jaune
melone giallo

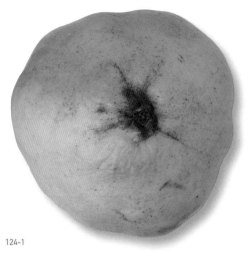

124-1

124-2

124-2

124-1	124-2	124-3
quince	quince	grapefruit
membrillo	membrillo	pomelo
Quitte	Quitte	Grapefruit
coing	coing	pamplemousse
cotogna	cotogna	pompelmo

125-1

quince
membrillo
Quitte
coing
cotogna

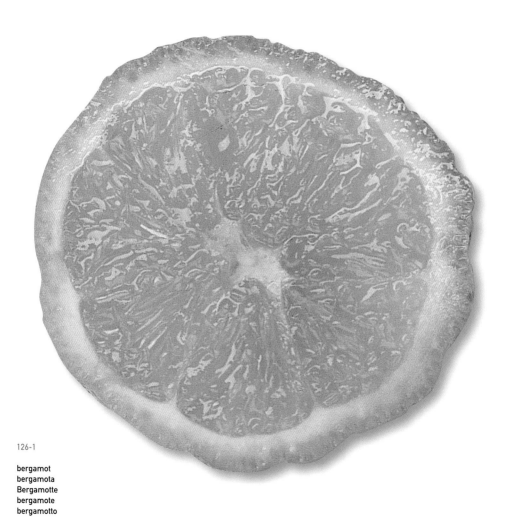

126-1

bergamot
bergamota
Bergamotte
bergamote
bergamotto

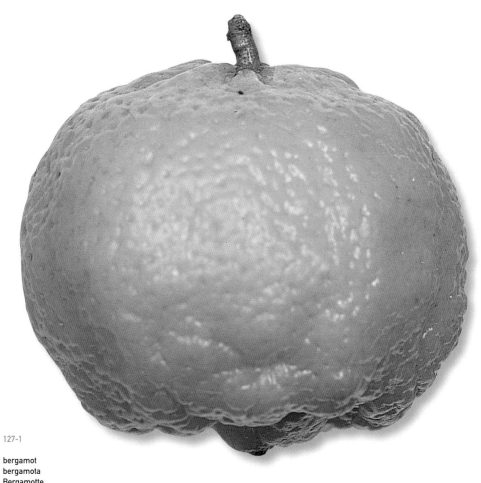

127-1

bergamot
bergamota
Bergamotte
bergamote
bergamotto

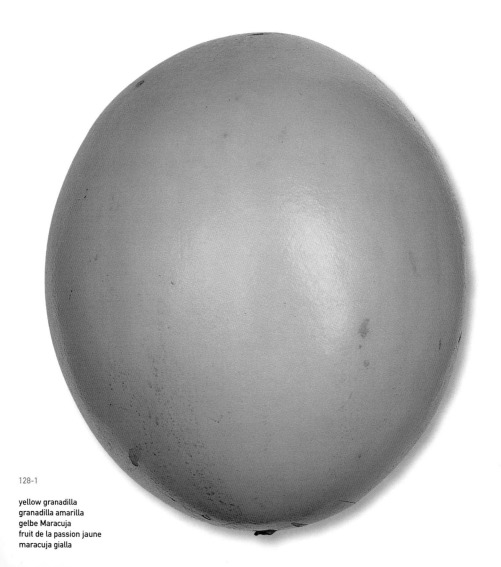

128-1

yellow granadilla
granadilla amarilla
gelbe Maracuja
fruit de la passion jaune
maracuja gialla

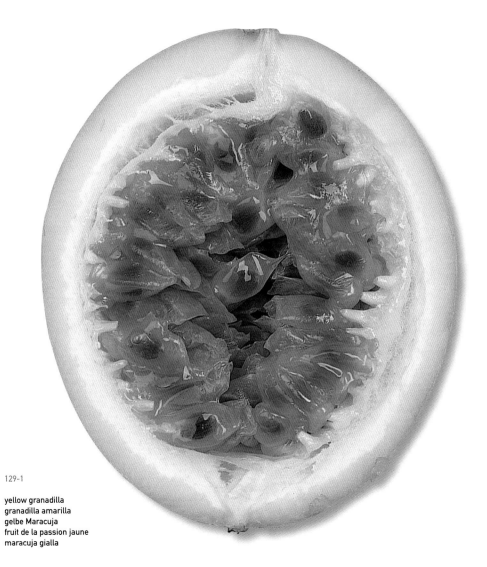

129-1

yellow granadilla
granadilla amarilla
gelbe Maracuja
fruit de la passion jaune
maracuja gialla

130-1

yellow pitahaya
pitahaya amarilla
gelbe Pitahaya
pitahaya jaune
pitahaya gialla

131-1

yellow pitahaya
pitahaya amarilla
gelbe Pitahaya
pitahaya jaune
pitahaya gialla

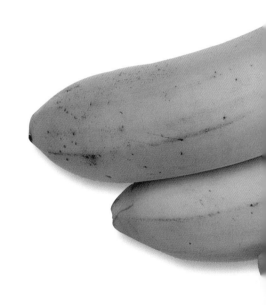

132-1

banana
plátano
Banane
banane
banana

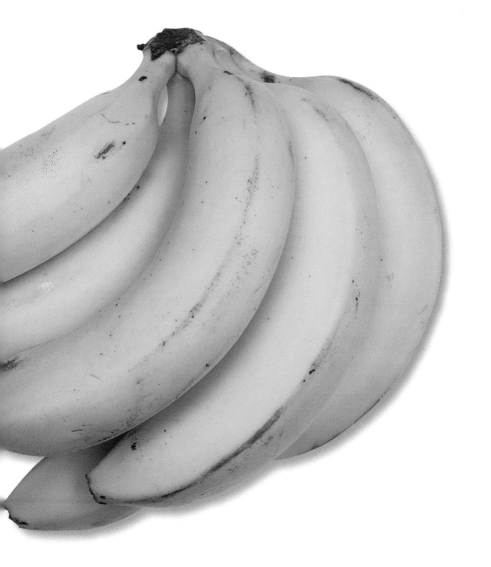

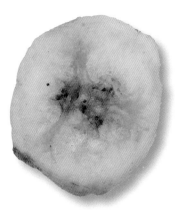

134-2

134-1

banana
plátano
Banane
banane
banana

134-2

dried banana
plátano seco
getrocknete Banane
banane séchée
banana disidratata

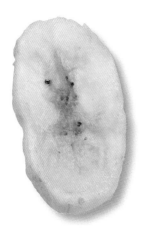

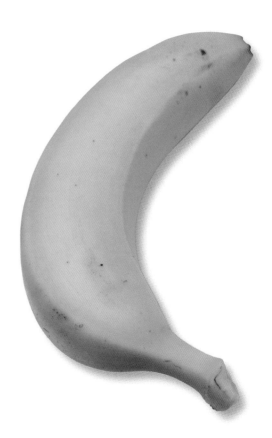

banana
plátano
Banane
banane
banana

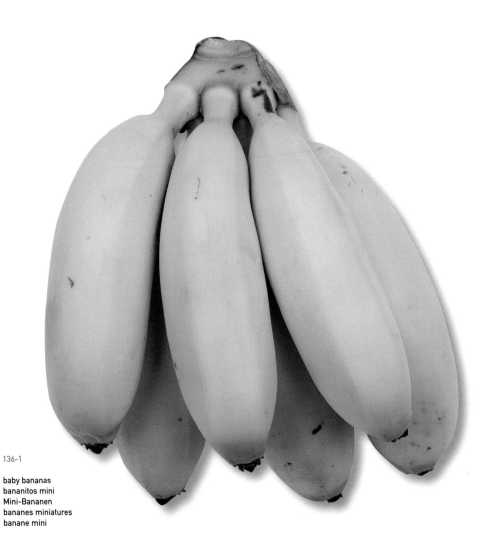

136-1

baby bananas
bananitos mini
Mini-Bananen
bananes miniatures
banane mini

137-1

137-2

137-3

137-1	137-2	137-3
banana	banana	banana
plátano	plátano	plátano
Banane	Banane	Banane
banane	banane	banane
banana	banana	banana

138-1

138-2

138-1

Nashi pear
pera asiática (nashi)
Nashi-Birne
nashi
nashi

138-2

Nashi pear
pera asiática (nashi)
Nashi-Birne
nashi
nashi

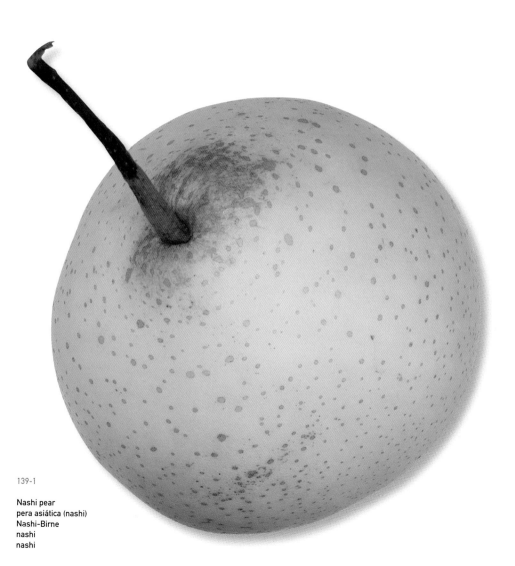

139-1

Nashi pear
pera asiática (nashi)
Nashi-Birne
nashi
nashi

140-1

140-2

140-2

140-1	140-2	140-3
chayote	chayote	chayote
chayote	chayote	chayote
Chayote	Chayote	Chayote
chayote	chayote	chayote
chayote	chayote	chayote

141-1

chayote
chayote
Chayote
chayote
chayote

142-1

Reineta apple
manzana reineta
Renette-Apfel
pomme Reinette
mela renetta

143-1

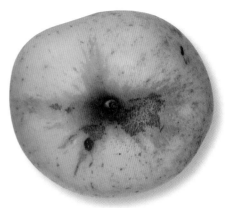

143-2

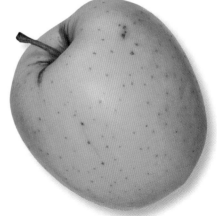

143-1

Reineta apple
manzana reineta
Renette-Apfel
pomme Reinette
mela renetta

143-2

Reineta apple
manzana reineta
Renette-Apfel
pomme Reinette
mela renetta

143-3

Golden Delicious apple
manzana Golden Delicious
Golden Delicious Apfel
pomme Golden Delicious
mele Golden Delicious 143-3

144-1

Maradal papaya
papaya maradol
Maradol-Papaya
papaye maradol
papaia maradol

146-1

Maradal papaya
papaya maradol
Maradol-Papaya
papaye maradol
papaia maradol

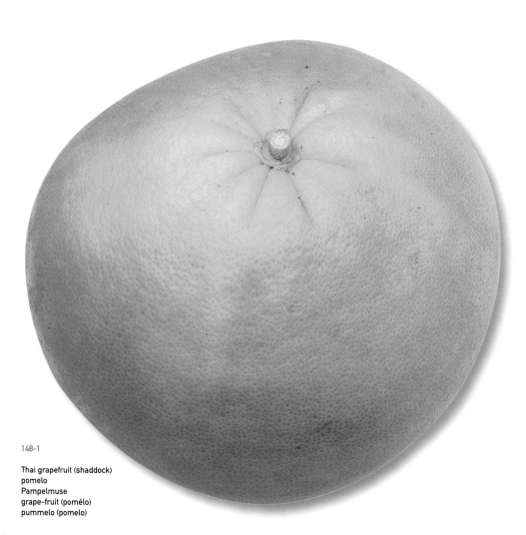

148-1

Thai grapefruit (shaddock)
pomelo
Pampelmuse
grape-fruit (pomélo)
pummelo (pomelo)

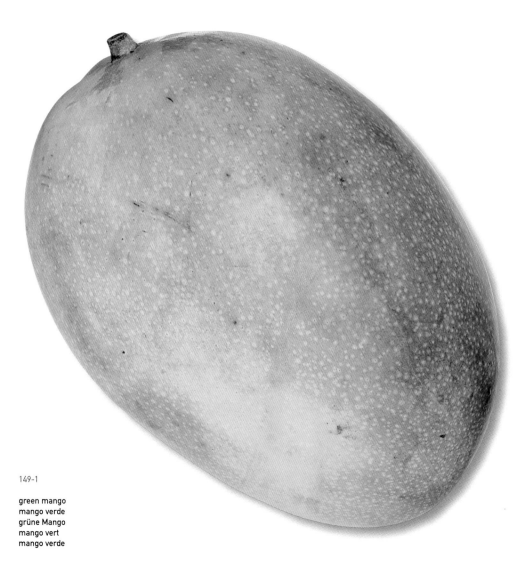

149-1

green mango
mango verde
grüne Mango
mango vert
mango verde

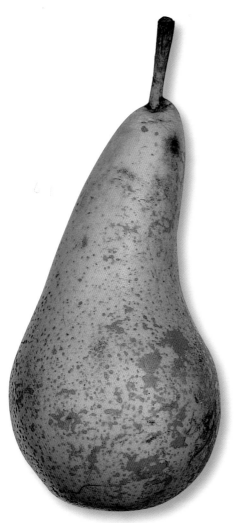

150-1

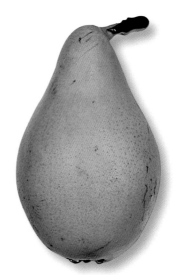

150-2

150-1

Conference pear
pera conference
Conference-Birne
poire conférence
pera conference

150-2

Blanquilla pear
pera blanquilla
Blanquilla-Birne
poire blanquilla
pera blanquilla

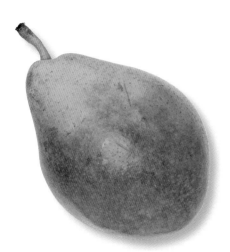

151-1

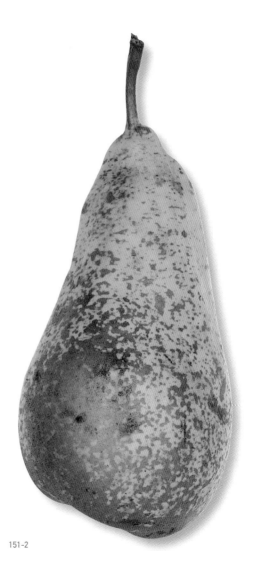

151-1

Puigcerdà pear
pera de Puigcerdà
Puigcerdà-Birne
poire de Puigcerdà
pera Puigcerdà

151-2

Conference pear
pera conference
Conference-Birne
poire conférence
pera conference

151-2

152-1

starfruit
carambola
Sternfrucht
carambola
carambole

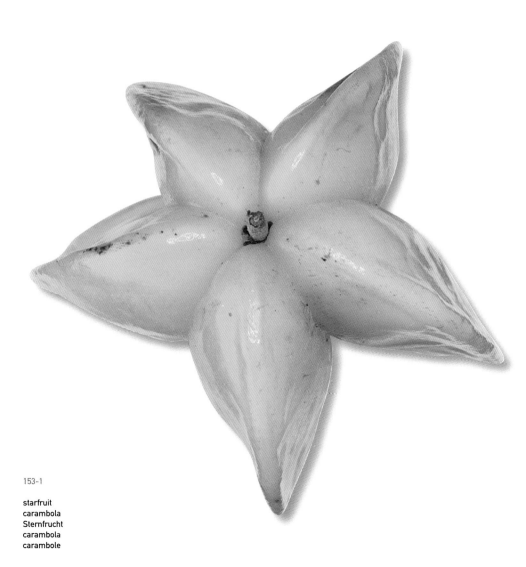

153-1

starfruit
carambola
Sternfrucht
carambola
carambole

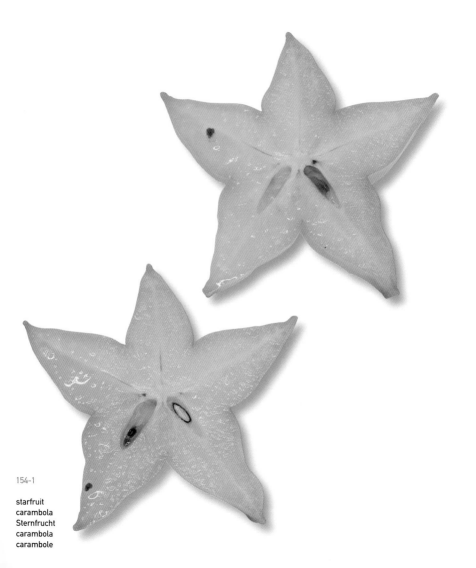

154-1

starfruit
carambola
Sternfrucht
carambola
carambole

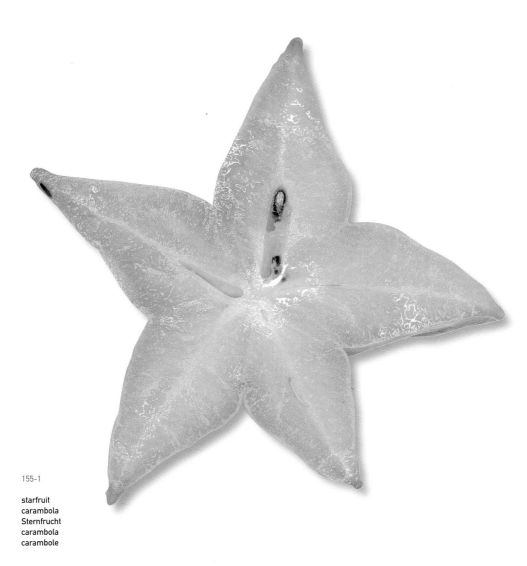

155-1

starfruit
carambola
Sternfrucht
carambola
carambole

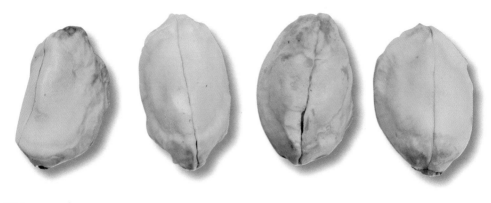

156-1

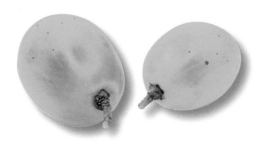

156-2

156-1	156-2
pistachios	green grape
pistachos	uva verde
Pistazien	grüne Weintraube
pistaches	grain de raisin vert
pistacchi	uva verde

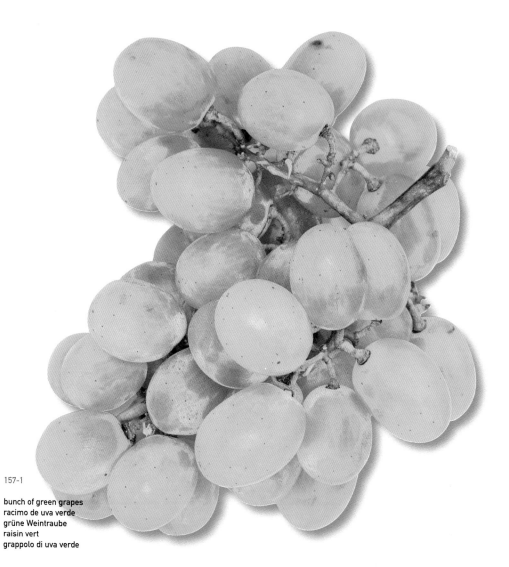

157-1

bunch of green grapes
racimo de uva verde
grüne Weintraube
raisin vert
grappolo di uva verde

158-1

158-2

158-2

158-1	158-2	158-3
Kaffir lime	**Kaffir lime**	**Kaffir lime**
lima Kaffir	lima Kaffir	lima Kaffir
Kaffir-Limette	Kaffir-Limette	Kaffir-Limette
lime kaffir	lime kaffir	lime kaffir
lime Kaffir	lime Kaffir	lime Kaffir

159-1

159-2

159-3

159-1	159-2	159-3
lime	lime	lime
lima	lima	lima
Limette	Limette	Limette
lime	lime	lime
lime	lime	lime

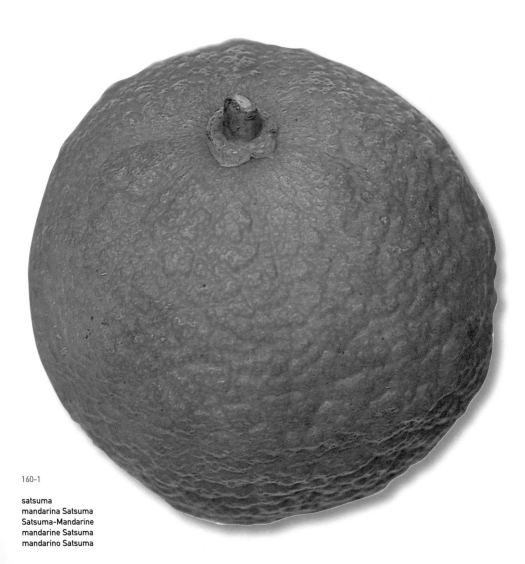

160-1

satsuma
mandarina Satsuma
Satsuma-Mandarine
mandarine Satsuma
mandarino Satsuma

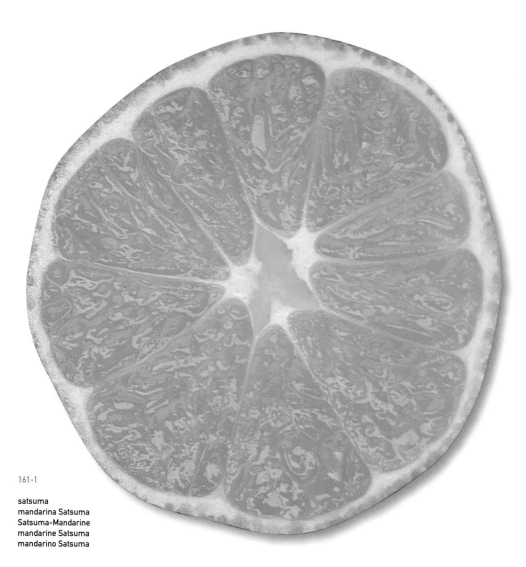

161-1

satsuma
mandarina Satsuma
Satsuma-Mandarine
mandarine Satsuma
mandarino Satsuma

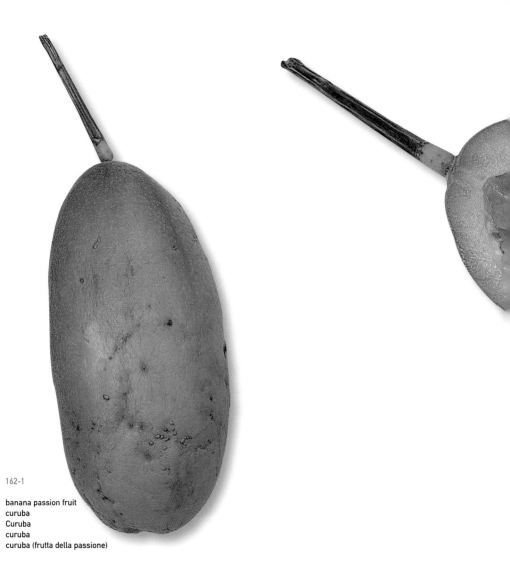

162-1

banana passion fruit
curuba
Curuba
curuba
curuba (frutta della passione)

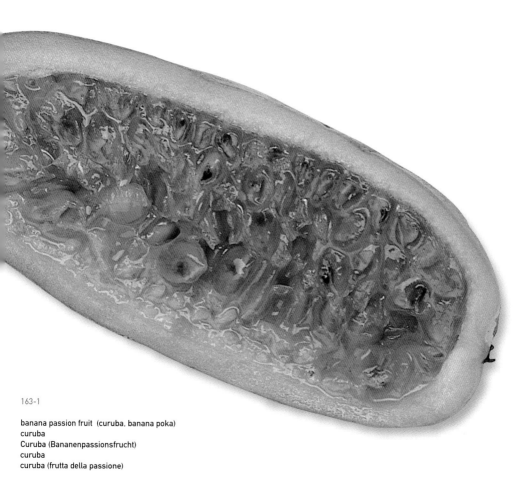

163-1

banana passion fruit (curuba, banana poka)
curuba
Curuba (Bananenpassionsfrucht)
curuba
curuba (frutta della passione)

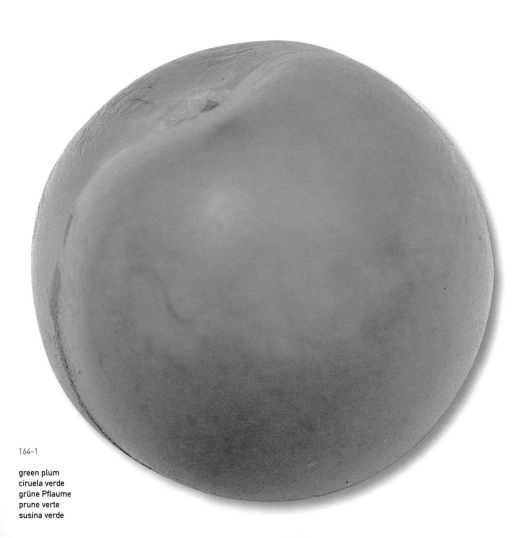

164-1

green plum
ciruela verde
grüne Pflaume
prune verte
susina verde

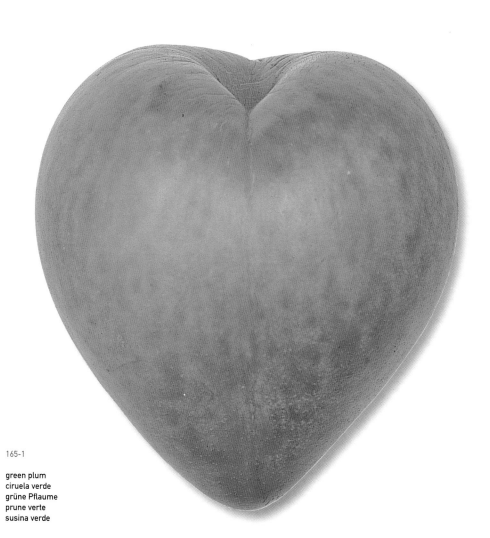

165-1

green plum
ciruela verde
grüne Pflaume
prune verte
susina verde

166-1

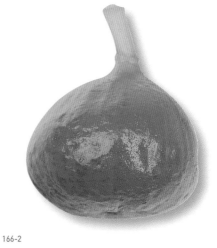

166-2

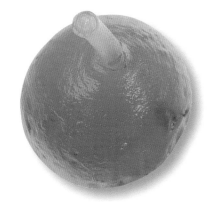

166-2

166-1	166-2	166-3
crystallised fig	crystallised fig	crystallised fig
higo confitado	higo confitado	higo confitado
kandierte Feige	kandierte Feige	kandierte Feige
figue confite	figue confite	figue confite
fico confettato	fico confettato	fico confettato

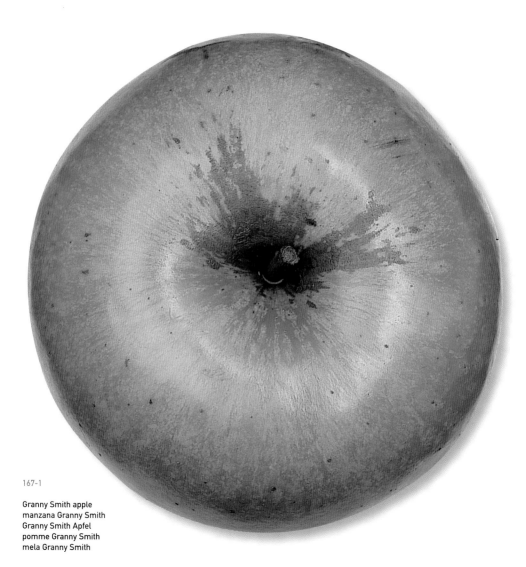

167-1

Granny Smith apple
manzana Granny Smith
Granny Smith Apfel
pomme Granny Smith
mela Granny Smith

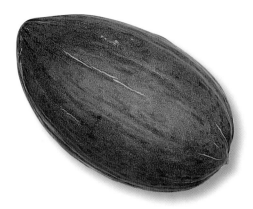

168-1

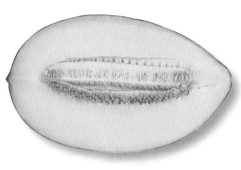

168-2

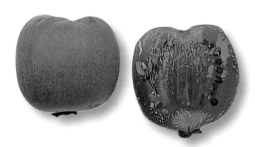

168-3

168-1. 168-2

Piel de Sapo melon
melón piel de sapo
Piel de Sapo-Melone
melon vert piel de sapo
melone piel de sapo

168-3

wild kiwifruit
kiwi silvestre
wilde Kiwi
kiwi sauvage
kiwi selvatico

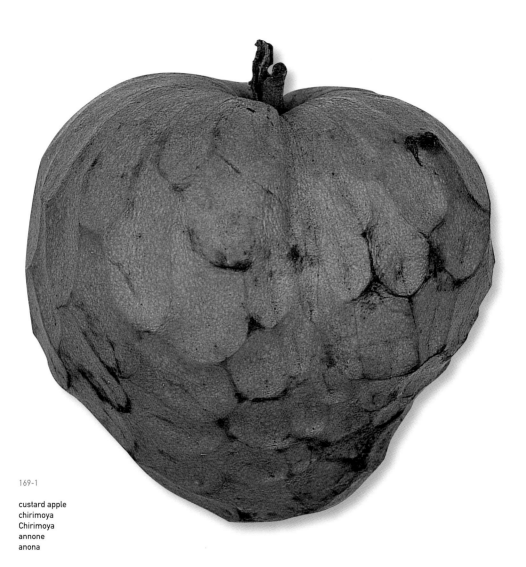

169-1

custard apple
chirimoya
Chirimoya
annone
anona

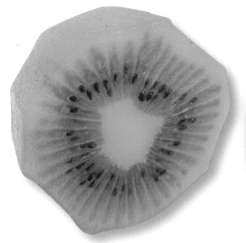

170-1

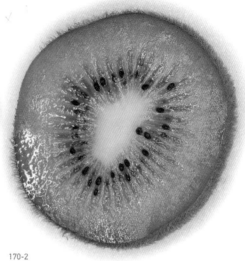

170-2

170-2

170-1	170-2	170-3
kiwi	kiwi	kiwi
kiwi	kiwi	kiwi
Kiwi	Kiwi	Kiwi
kiwi	kiwi	kiwi
kiwi	kiwi	kiwi

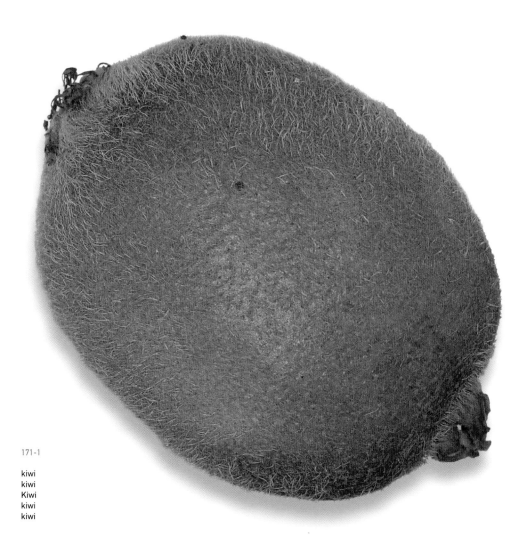

171-1

kiwi
kiwi
Kiwi
kiwi
kiwi

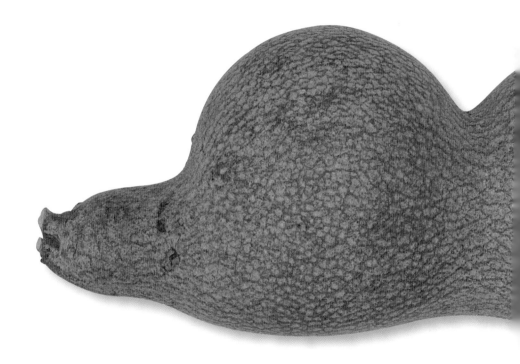

172-1

tamarind
tamarindo
Tamarinde
tamarin
tamarindo

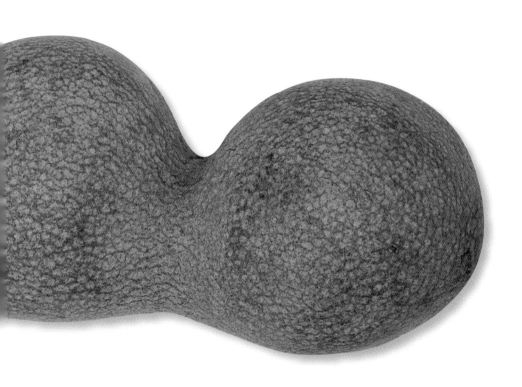

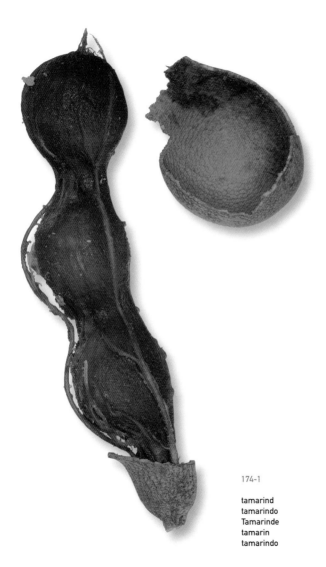

174-1

tamarind
tamarindo
Tamarinde
tamarin
tamarindo

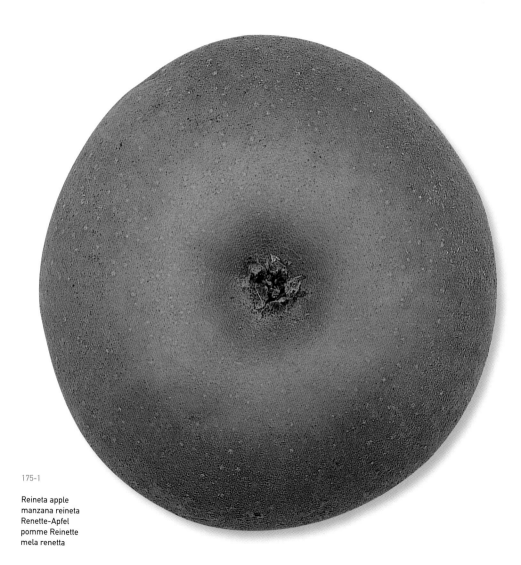

175–1

Reineta apple
manzana reineta
Renette-Apfel
pomme Reinette
mela renetta

176-1

dried date
dátil seco
getrocknete Dattel
date séchée
dattero disidratato

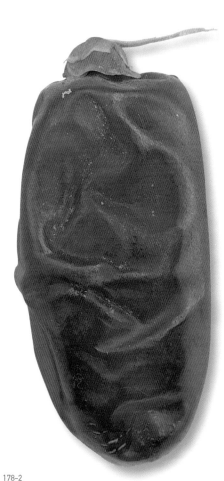

178-2

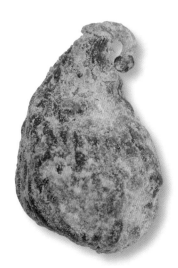

178-2

178-1

dried date
dátil seco
getrocknete Dattel
date séchée
dattero disidratato

178-2

dried figs
higos secos
getrocknete Feigen
figues séchées
fichi secchi

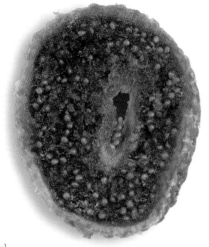

179-1

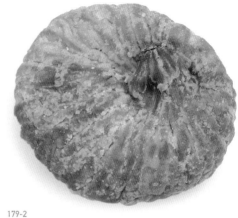

179-2

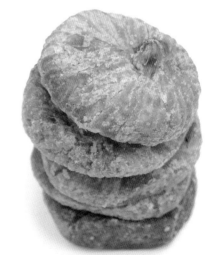

179-3

179-1	179-2	179-3
dried figs	dried figs	dried figs
higos secos	higos secos	higos secos
getrocknete Feigen	getrocknete Feigen	getrocknete Feigen
figues séchées	figues séchées	figues séchées
fichi secchi	fichi secchi	fichi secchi

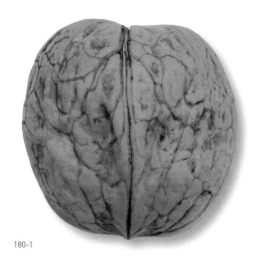

180-1

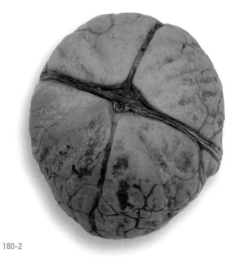

180-2

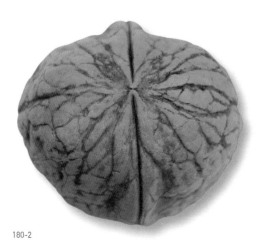

180-2

180-1	180-2	180-3
walnut	walnut	walnut
nuez	nuez	nuez
Walnuss	Walnuss	Walnuss
noix	noix	noix
noce	noce	noce

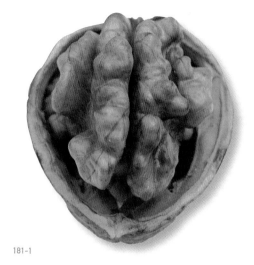

181-1

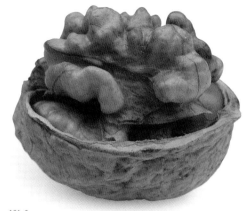

181-2

181-1

walnut
nuez
Walnuss
noix
noce

181-2

walnut
nuez
Walnuss
noix
noce

181-3

walnut
nuez
Walnuss
noix
noce

181-3

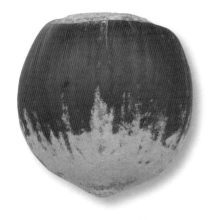

182-1

182-2

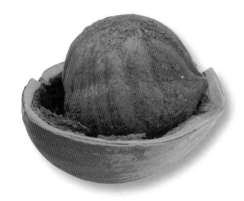

182-2

182-1	182-2	182-3
hazelnut	hazelnut	hazelnut
avellana	avellana	avellana
Haselnuss	Haselnuss	Haselnuss
noisette	noisette	noisette
nocciola	nocciola	nocciola

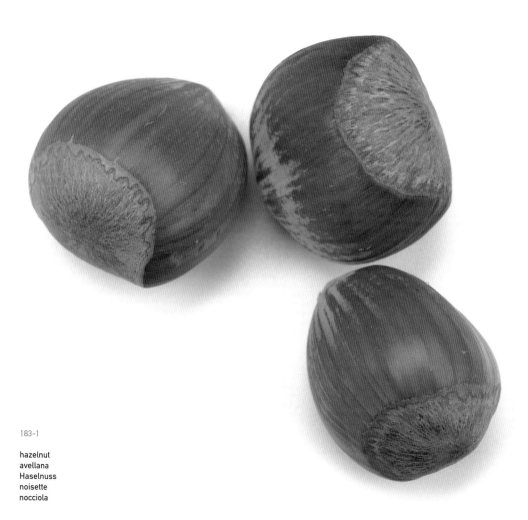

183-1

hazelnut
avellana
Haselnuss
noisette
nocciola

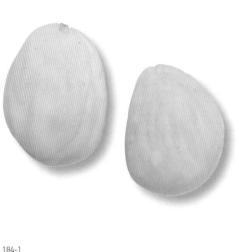

184-1

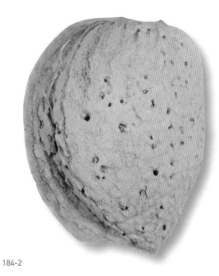

184-2

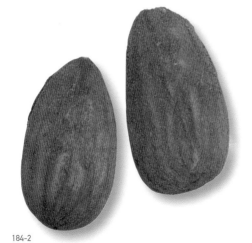

184-2

184-1	184-2	184-3
almond	almond	almond
almendra	almendra	almendra
Mandel	Mandel	Mandel
amande	amande	amande
mandorla	mandorla	mandorla

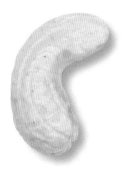

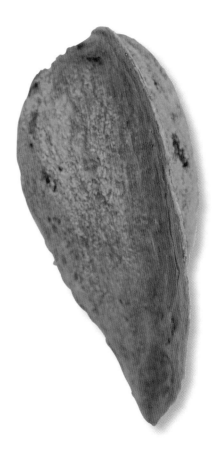

185-1

185-1

cashew
anacardo
Cashew-Nuss
noix de cajou
anacardio

185-2

almond
almendra
Mandel
amande
mandorla

185-2

186-1

coconut
coco
Kokosnuss
noix de coco
noce di cocco

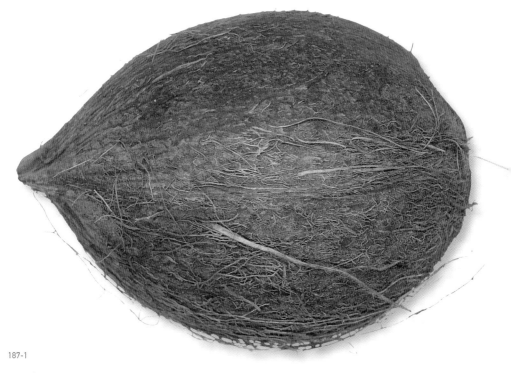

187-1

coconut
coco
Kokosnuss
noix de coco
noce di cocco

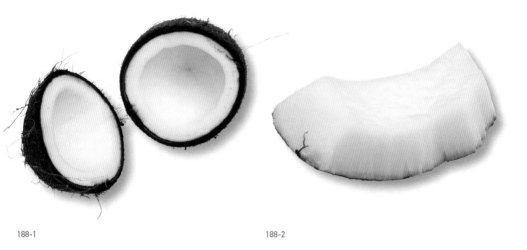

188-1

188-2

188-2

188-1	188-2	188-3
coconut	coconut	coconut
coco	coco	coco
Kokosnuss	Kokosnuss	Kokosnuss
noix de coco	noix de coco	noix de coco
noce di cocco	noce di cocco	noce di cocco

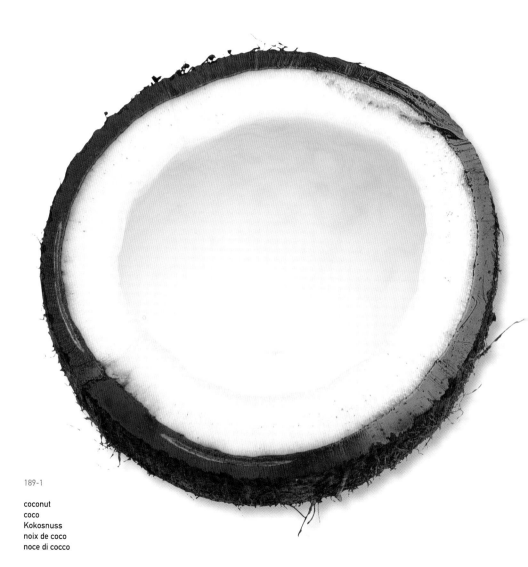

189-1

coconut
coco
Kokosnuss
noix de coco
noce di cocco

190-1

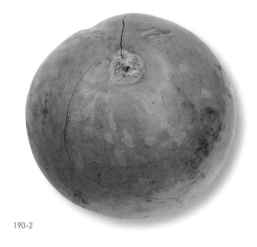

190-2

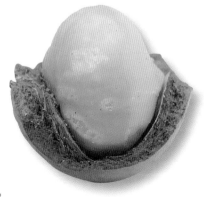

190-2

190-1	190-2	190-3
Brazil nut	macadamia nut	macadamia nut
nuez del Brasil	nuez de macadamia	nuez de macadamia
Paranuss	Macadamia-Nuss	Macadamia-Nuss
noix du Brésil	noix de macadamia	noix de macadamia
noce del Brasile	noce di Macadamia	noce di Macadamia

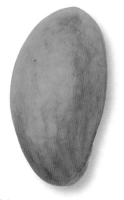

191-1

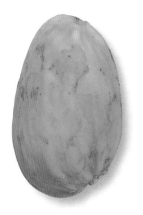

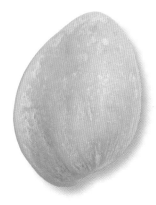

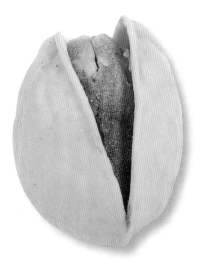

191-1

varieties of pistachio
variedades de pistachos
verschiedene Pistazien
variétés de pistache
varietà di pistacchio

191-2

Iranian pistachios
pistachos iraníes
iranische Pistazien
pistaches
iraniennes
pistacchi iraniani

191-2

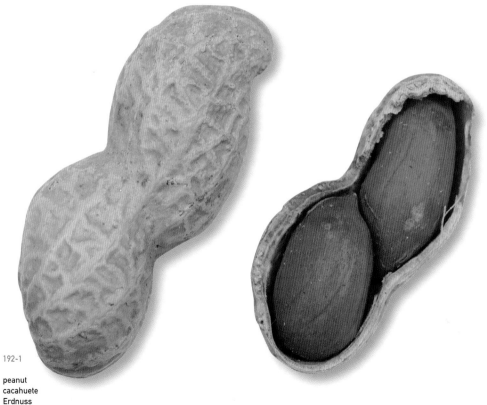

192-1

peanut
cacahuete
Erdnuss
cacahuète
arachide

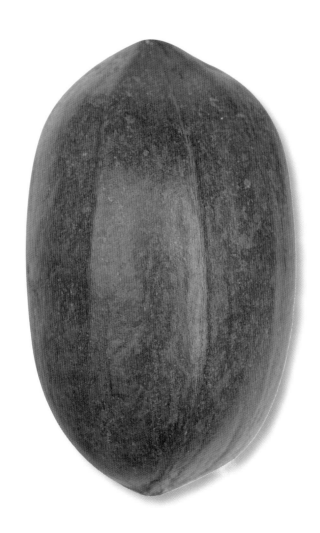

193-1

pecan nut
nuez pecana
Pekannuss
noix de pécan
pecan

194-1

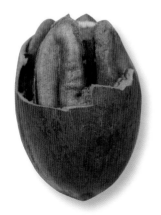

194-2

194-1

pecan nut
nuez pecana
Pekannuss
noix de pécan
pecan

194-2

pecan nut
nuez pecana
Pekannuss
noix de pécan
pecan

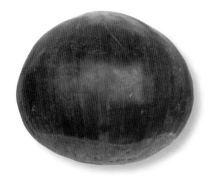

195-1

195-2

195-1	195-2
sweet chestnut	sweet chestnut
castaña	castaña
Esskastanie	Esskastanie
châtaigne	châtaigne
castagna dolce	castagna dolce

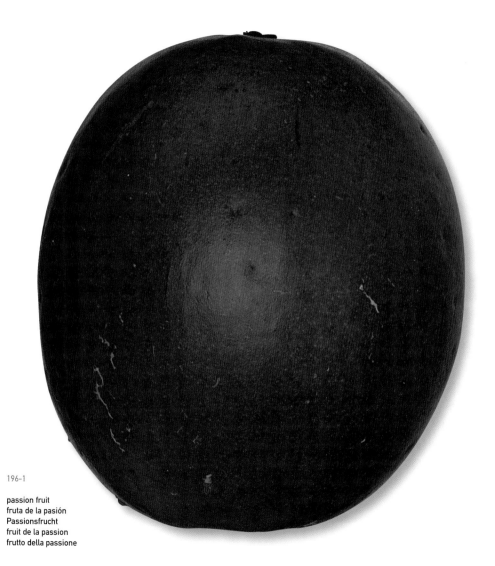

196-1

passion fruit
fruta de la pasión
Passionsfrucht
fruit de la passion
frutto della passione

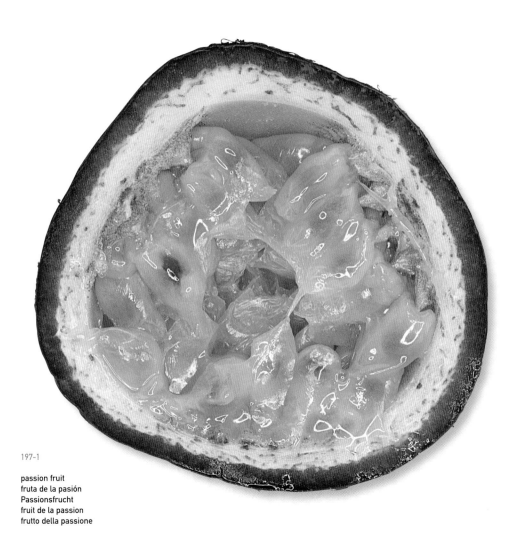

197-1

passion fruit
fruta de la pasión
Passionsfrucht
fruit de la passion
frutto della passione

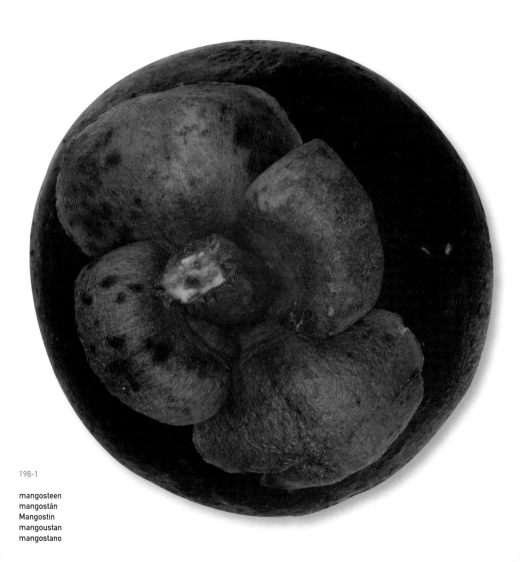

198-1

mangosteen
mangostán
Mangostin
mangoustan
mangostano

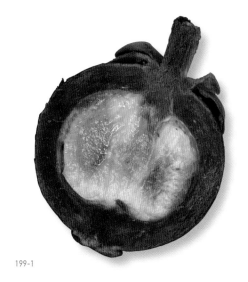

199-1

199-2

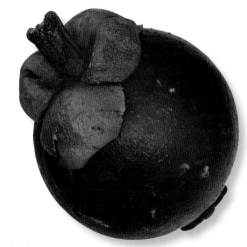

199-3

199-1	199-2	199-3
mangosteen	mangosteen	mangosteen
mangostán	mangostán	mangostán
Mangostin	Mangostin	Mangostin
mangoustan	mangoustan	mangoustan
mangostano	mangostano	mangostano

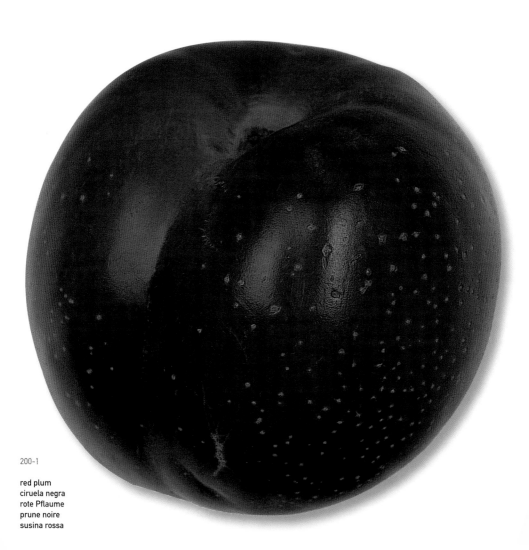

200-1

red plum
ciruela negra
rote Pflaume
prune noire
susina rossa

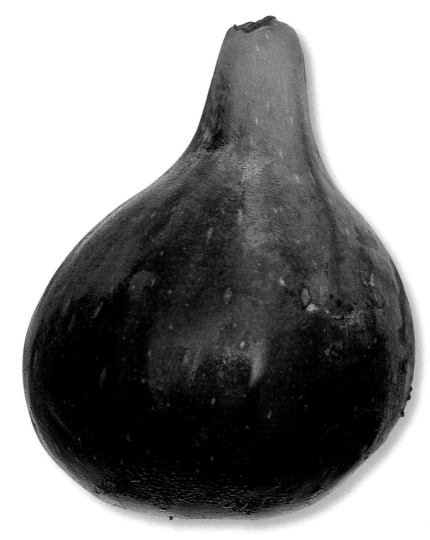

fig
higo
Feige
figue
fico

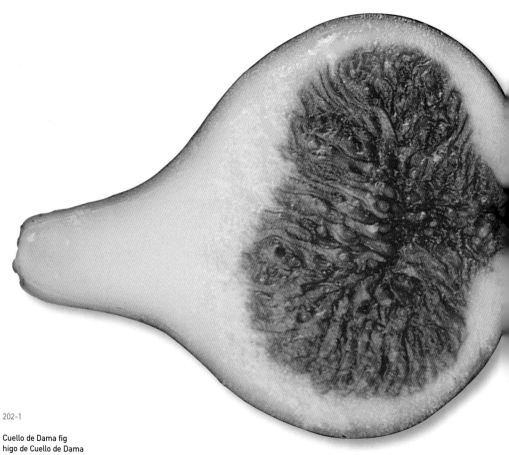

202-1

Cuello de Dama fig
higo de Cuello de Dama
Cuello de Dama-Feige
figue Col de Dame
fico Cuello de Dama

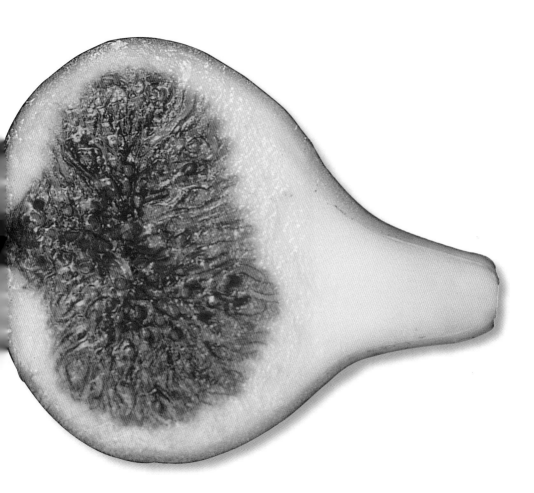

204-1

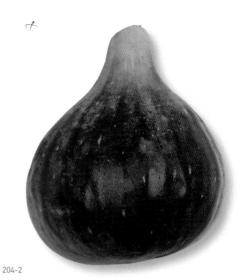

204-2

204-2

204-1	204-2	204-3
fig	fig	fig
higo	higo	higo
Feige	Feige	Feige
figue	figue	figue
fico	fico	fico

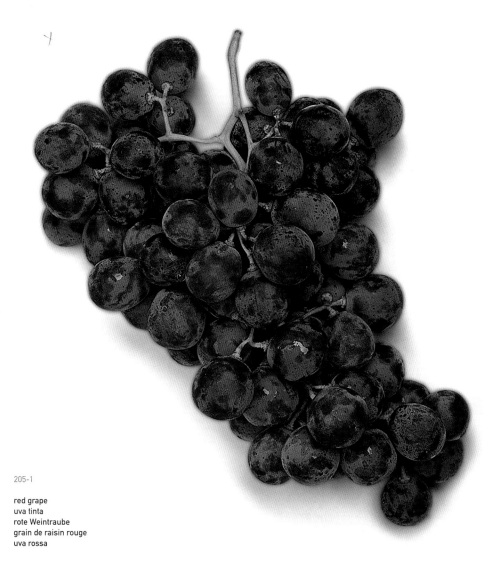

205-1

red grape
uva tinta
rote Weintraube
grain de raisin rouge
uva rossa

206-1

red grape
uva tinta
rote Weintraube
grain de raisin rouge
uva rossa

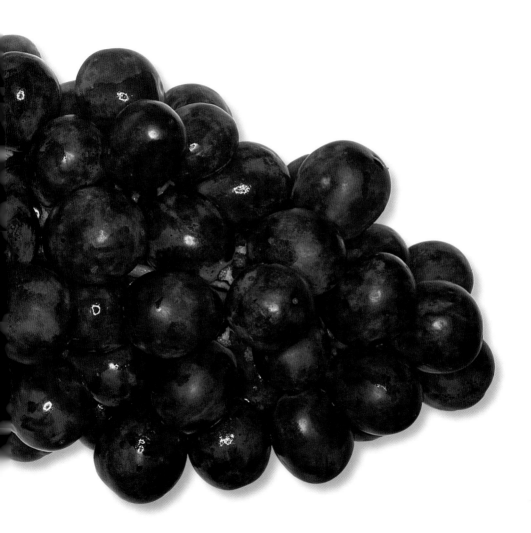

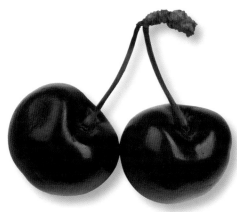

208-2

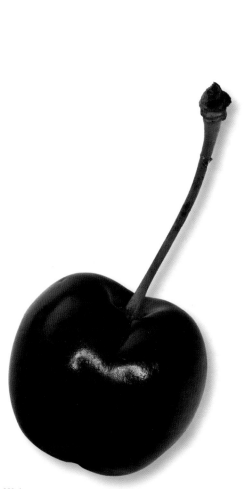

208-1

208-1	208-2
cherry	cherry
cereza	cereza
Kirsche	Kirsche
cerise	cerise
ciliegia	ciliegia

209-1

cherry
cereza
Kirsche
cerise
ciliegia

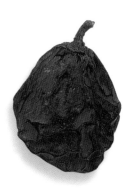
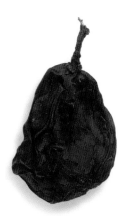

210-1

raisins
pasas
Rosinen
raisins secs
uva passa

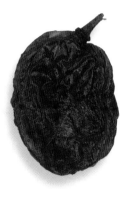
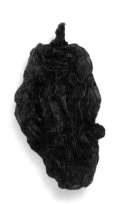
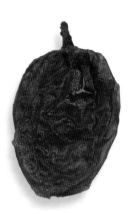

211-1

raisins
pasas
Rosinen
raisins secs
uva passa

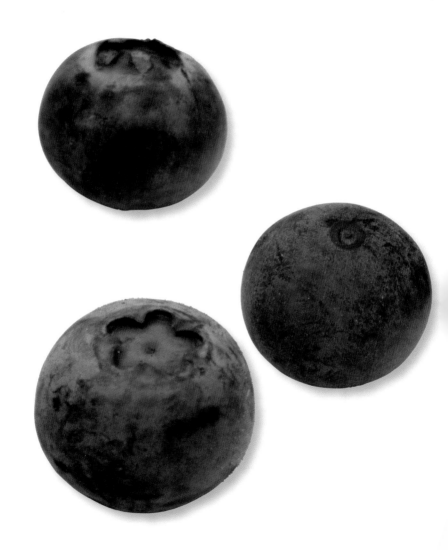

212-1

blueberry
arándano
Blaubeere
myrtille
mirtillo

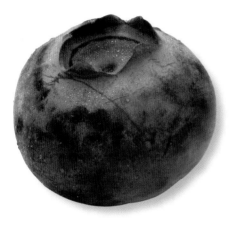
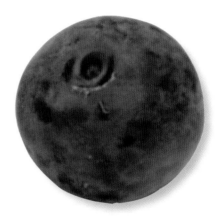

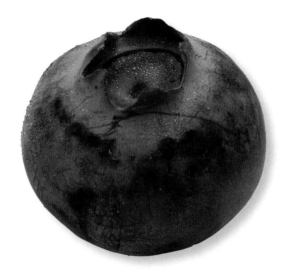

214-1

blueberry
arándano
Blaubeere
myrtille
mirtillo

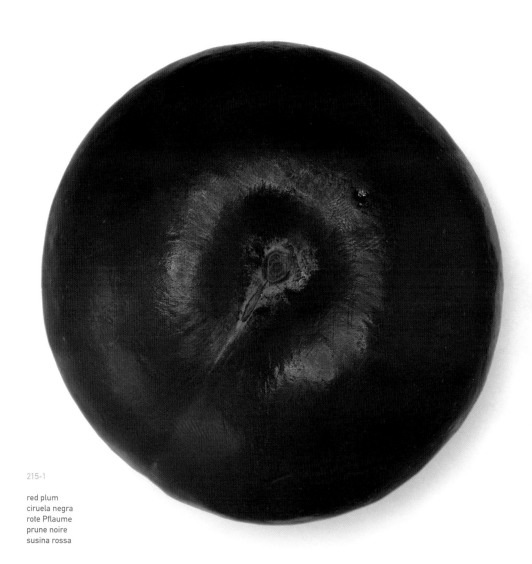

215-1

red plum
ciruela negra
rote Pflaume
prune noire
susina rossa

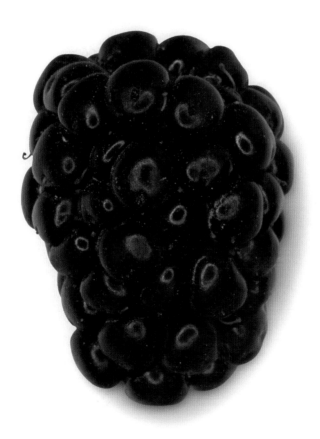

216-1

blackberry
mora
Brombeere
mûre
mora

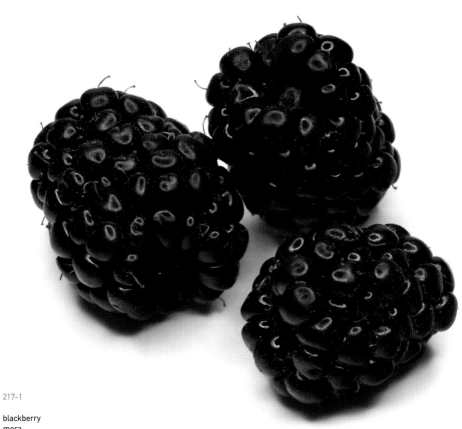

217-1

blackberry
mora
Brombeere
mûre
mora

Index

A

abricot	62, 63
abricots secs	67
albaricoque	62, 63
albicocca	62, 63
albicocche disidratate	67
alchechengi	52, 54, 55
almendra	184, 185
almond	184, 185
alquequenje	52, 54, 55
amande	184, 185
anacardio	185
anacardo	185
Ananas	92, 93, 94, 96
ananas	92, 93, 94, 96
ananas américain	94, 96
ananas baby	92, 96
ananas candita	93
ananas confit	93
ananas miniature	92, 96
anguria	44, 45
anguria gialla	97
annone	169
anona	169
Apfel	100 - 103
apple	100 - 103
apricot	62, 63
Aprikose	62, 63
arachide	192
arancia	76, 77
arancia confettata	68, 69
arancia rossa	70, 71
arándano	212, 214
arbouse	42, 43
avellana	182, 183

B

baby bananas	136
baby pineapple	92, 96
banana	132, 134, 135, 137
banana disidratata	134
banana passion fruit	162
banana passion fruit (curuba, banana poka)	163
Banane	132, 134, 135, 137
banane	132, 134, 135, 137
bananes miniatures	136

banane mini	136
banane séchée	134
bananitos mini	136
Baumtomate	48
bergamot	126, 127
bergamota	126, 127
bergamote	126, 127
Bergamotte	126, 127
bergamotto	126, 127
blackberry	216, 217
Blanquilla-Birne	150
Blanquilla pear	150
Blaubeere	212, 214
blood orange	70, 71
blueberry	212, 214
Blutorange	70, 71
bolitas de melón	45, 97
boules de melon	45, 97
Brazil nut	190
brocheta de frutas	50
Brombeere	216, 217
bunch of green grapes	157

C

cacahuete	192
Cantaloupe-Melone	88, 89
Cantaloupe melon	88, 89
carambola	152 - 155
cashew	185
Cashew-Nuss	185
castagna dolce	195
castaña	195
Cavaillon-Melone	90, 91
Cavaillon melon	90, 91
cereza	18, 19, 208, 209
cerise	18, 19, 208, 209
châtaigne	195
Chayote	140, 141
chayote	140, 141
cherry	18, 19, 208, 209
Chirimoya	169
chirimoya	169
ciliegia	18, 19, 208, 209
ciruela amarilla	58, 59, 60, 68
ciruela negra	200, 215
ciruela verde	164, 165

citron	108, 110, 112 - 116, 118
coco	186 - 189
coconut	186 - 189
coing	124, 125
Conference-Birne	150, 151
Conference pear	150, 151
corbezzolo	42, 43
cotogna	124, 125
crystallised fig	166
crystallised orange	68, 69
crystallised pear	107
crystallised pineapple	93
Cuello de Dama-Feige	202
Cuello de Dama fig	202
Curuba (Bananenpassionsfrucht)	162, 163
curuba (frutta della passione)	162, 163
custard apple	169

D

date séchée	176, 178
dátil seco	176, 178
dattero disidratato	176, 178
dried banana	134
dried date	176, 178
dried figs	178, 179

E

dried apricots	67
Erdbeere	16, 17
Erdnuss	192
Esskastanie	195

F

Feige	201, 204
fichi secchi	178, 179
fico	201, 204
fico confettato	166
fico Cuello de Dama	202
fico d'India	56
fig	201, 204
figue	201, 204
figues séchées	178, 179
figue Col de Dame	202
figue confite	166

figue de Barbarie	56
Formosa-Papaya	81, 82
Formosa papaya	81, 82
fragola	16, 17
fragole di bosco	14
fraise	16, 17
fraises des bois	14
framboise	14
fresas silvestres	14
fresón	16, 17
frozen berries	15
Früchtespieß	50
Frucht des Erdbeerbaums	42, 43
fruits rouges surgelés	15
fruit de la passion	196, 197
fruit de la passion jaune	128, 129
fruit kebab	50
fruit of the strawberry tree	42, 43
frutas del bosque congeladas	15
fruta de la pasión	196, 197
frutti di bosco congelati	15
frutto della passione	196, 197
Fuji-Apfel	22, 23
Fuji apple	22, 23

G

Galia-Melone	86, 87
Galia melon	86, 87
gefrorene Beeren	15
gelbe Pflaume	58 - 60, 68
gelbe Maracuja	128, 129
gelbe Melone	122
gelbe Pitahaya	130, 131
gelbe Wassermelone	97
getrocknete Aprikosen	67
getrocknete Banane	134
getrocknete Dattel	176, 178
getrocknete Feigen	178, 179
Golden Delicious Apfel	98, 99, 143
Golden Delicious apple	98, 99, 143
grain de raisin rouge	205, 206
grain de raisin vert	156
granada	32 - 35
granadilla amarilla	128, 129
Granatapfel	33, 35
Granny Smith apple	167

Granny Smith Apfel 167
grape-fruit (pomélo) 119 - 121, 148
Grapefruit 124
grapefruit 124
grappolo di uva verde 157
green grape 156
green mango 149
green plum 164, 165
grenade 32 - 35
groseille rouge 12
grosella roja 12
grüne Mango 149
grüne Pflaume 164, 165
grüne Weintraube 156, 157

H

Haselnuss 182, 183
hazelnut 182, 183
higo 201, 204
higos secos 178, 179
higo chumbo 56
higo confitado 166
higo de Cuello de Dama 202
Himbeere 14

I

Iranian pistachios 191
iranische Pistazien 191

K

Kaffir-Limette 158
Kaffir lime 158
Kaktusfeige 56
kandierte Ananas 93
kandierte Birne 107
kandierte Feige 166
kandierte Orange 68, 69
Kapstachelbeere 54, 55
Kirsche 18, 19, 208, 209
Kiwi 170, 171
kiwi sauvage 168
kiwi selvatico 168
kiwi silvestre 168
Kokosnuss 186 - 189

Kumquat 78, 79
kumquat

L

lampone 14
lemon 108, 110, 112 - 116, 118
lichi 38, 39
lima 159
lima Kaffir 158
lime 159
Limette 159
lime Kaffir 158
limón 108, 110, 112 - 116, 118
limone 108, 110, 112 - 116, 118
litchi 38, 39
Litschi 38, 39
loquat 84, 85
lychee 38, 39

M

Macadamia-Nuss 190
macadamia nut 190
madroño 42, 43
mandarina 74, 75
mandarina Satsuma 160, 161
Mandarine 74, 75
mandarine 74, 75
mandarine Satsuma 160, 161
mandarino 74, 75
mandarino cinese 78, 79
mandarino Satsuma 160, 161
mandarin orange 74, 75
Mandel 184, 185
mandorla 184, 185
Mango 26, 27
mangostán 198, 199
mangostano 198, 199
mangosteen 198, 199
Mangostin 198, 199
mangoustan 198, 199
mango verde 149
mango vert 149
Mangue 26, 27
manzana 100 - 103
manzana fuji 22, 23

kumquat 78, 79

manzana Golden Delicious	98, 99, 143
manzana Granny Smith	167
manzana reineta	142, 143, 175
manzana roja	22, 24, 25
maracuja gialla	128, 129
Maradal papaya	144, 146
Maradol-Papaya	144, 146
mela	100 - 103
mela fuji	22, 23
mela Granny Smith	167
mela Red Delicious	22
mela renetta	142, 143, 175
mela Starking	24, 25
mele Golden Delicious	98, 99, 143
melocotón	22
melocotón viña	66
melograno	32 - 35
Melonenbällchen	45, 97
melone cantalupo	88, 89
melone di Cavaillon	90, 91
melone Galia	86, 87
melone giallo	122
melone piel de sapo	168
melón amarillo	122
melon balls	45, 97
melon Cantaloup	88, 89
melón cantalupo	88, 89
melon de Cavaillon	90, 91
melón Galia	86, 87
melon Gallia	86, 87
melon jaune	122
melón piel de sapo	168
melon vert piel de sapo	168
membrillo	124, 125
Mini-Ananas	92, 96
Mini-Bananen	136
mirtillo	212 - 214
mirtilloa	212
Mispel	84, 85
mora	216, 217
mûre	216, 217
myrtille	
	212, 214

N

naranja	76, 77
naranja confitada	68, 69
naranja sanguina	70, 71
Naranjilla (Lulo)	80
nashi	138, 139
Nashi-Birne	138, 139
Nashi pear	138, 139
nectarina	20, 21, 60, 61, 64, 65
nectarine	20, 21, 60, 61, 64, 65
nèfle	84, 85
Nektarine	20, 21, 60, 61, 64, 65
nespola	84, 85
níspero	84, 85
nocciole	182
noce	180, 181
noce del Brasile	190
noce di cocco	186 - 189
noce di Macadamia	190
noisettes	182, 183
noix	180, 181
noix de cajou	185
noix de coco	186, 189
noix de macadamia	190
noix de pécan	193, 194
noix du Brésil	190
nuez	180, 181
nuez del Brasil	190
nuez de macadamia	190
nuez pecana	193, 194

O

Orange	76, 77
orange confite	68, 69
orange sanguine	70, 71
orejones de albaricoque	67

P

palline di melone	45, 97
Pampelmuse	119 - 121, 148
pamplemousse	124
pamplemousse rose	72, 73, 80
papaia Formosa	81, 82
papaia maradol	144
papaya formosa	81, 82
papaya maradol	144, 146
papaye formosa	81, 82
papaye maradol	144, 146

Paranuss	190	
pasas	210, 211	
Passionsfrucht	196, 197	
passion fruit	196, 197	
pastèque	44, 45	
pastèque jaune	97	
peach	22, 66	
peanut	192	
pecan	193, 194	
pecan nut	193, 194	
pêche	22, 66	
Pekannuss	193, 194	
pera asiática (nashi)	138, 139	
pera blanquilla	150	
pera conference	150, 151	
pera confettata	107	
pera confitada	107	
pera de Puigcerdà	151	
pera de San Juan	104, 106, 107	
pera di San Juan	104, 106, 107	
pera Puigcerdà	151	
pesca	22, 66	
pesca noce	20, 21, 60, 61, 64, 65	
Pfirsich	22, 66	
Physalis	52, 54, 55	
Piel de Sapo-Melone	168	
Piel de Sapo melon	168	
piña	92, 93	
piña americana	94, 96	
piña baby	92, 96	
piña confitada	93	
pineapple	92 - 94, 96	
pink grapefruit	72, 73, 80	
pistacchi	46, 156	
pistacchi iraniani	191	
pistaches	46, 156	
pistaches iraniennes	191	
pistachios	46, 156	
pistachos	46, 156	
pistachos iraníes	191	
Pistazien	46, 156	
Pitahaya (Drachenfrucht)	28, 30	
pitahaya (dragon fruit)	28, 30	
pitahaya (fruta del dragón)	28, 30	
pitahaya (frutto del dragone)	28, 30	
pitahaya amarilla	130, 131	
pitahaya gialla	130, 131	

pitahaya jaune	130, 131	
pitaya (fruit du dragon)	28, 30	
plátano	132, 134, 135, 137	
plátano seco	134	
poire blanquilla	150	
poire conférence	150, 151	
poire confite	107	
poire de la Saint Jean	104, 106, 107	
poire de Puigcerdà	151	
pomegranate	32 - 35	
pomelo	119 - 121, 124, 148	
pomelo rosa	72, 73, 80	
pomme	100 - 103	
pomme fuji	22, 23	
pomme Golden Delicious	98, 99, 143	
pomme Granny Smith	167	
pomme Red Delicious	22	
pomme Reinette	142, 143, 175	
pomme Starking	24, 25	
pomodoro arboreo	48, 49	
pompelmo	124	
pompelmo rosa	72, 73, 80	
prickly pear	56	
prune jaune	58, 59, 60, 68	
prune noire	200, 215	
prune verte	164, 165	
Puigcerdà-Birne	151	
Puigcerdà pear	151	
pummelo (pomelo)	119 - 121, 124, 148	

Q

quince	124, 125	
Quitte		
	124, 125	

R

rabarbarob	40	
racimo de uva verde	157	
raisins	210, 211	
raisins secs	210, 211	
raisin vert	157	
ramboutan	35 - 37	
Rambutan	35 - 37	
rambutan	35 - 37	
rambután	35 - 37	
raspberry	14	

redcurrant 12
Red Delicious apple 22
red grape 205, 206
red plum 200, 215
Reineta apple 142, 143, 175
Renette-Apfel 142, 143, 175
Rhabarber 40
rhubarb 40
rhubarbe 40
ribes 12
rosa Grapefruit 72, 73, 80
Rosinen 210, 211
roter Delicious-Apfel 22
rote Johannisbeere 12
rote Pflaume 200, 215
rote Weintraube 205
ruibarbo 40

S

sandía 44, 45
sandía amarilla 97
San Juan pear 104, 106, 107
satsuma 160, 161
Satsuma-Mandarine 160, 161
spiedino di frutta 50
starfruit 152 - 155
Starking-Apfel 24, 25
Starking apple 24, 25
Sternfrucht 152 - 155
strawberry 16, 17
susina gialla 58 - 60, 68
susina rossa 200, 215
susina verde 164, 165
sweet chestnut 195, 195

T

tamarin 172, 174
tamarind 172, 174
Tamarinde 172, 174
tamarindo 172, 174
Thai grapefruit (shaddock) 119 - 121, 148
tomate d'arbre 48, 49
tomate de árbol 48, 49
tree tomato 48, 49

U

uva passa 210, 211
uva rossa 205, 206
uva tinta 205, 206
uva verde 156

V

variedades de pistachos 191
varietà di pistacchio 191
variétés de pistache 191
varieties of pistachio 191
verschiedene Pistazien 191

W

Walderdbeeren 14
Walnuss 180, 181
walnut 180, 181
Wassermelone 44, 45
watermelon 44, 45
wilde Kiwi 168
wild kiwifruit 168
wild strawberries 14

Y

yellow granadilla 128, 129
yellow melon 122
yellow pitahaya 130, 131
yellow plum 58, 60, 68
yellow watermelon 97

Z

Zitrone 108, 110, 112 - 116, 118
Zuckerbirne 104, 106, 107142, 143, 175